KINGS in Their CASTLES

KINGS in Their CASTLES

Photographs of Queer Men at Home

TOM ATWOOD

Foreword by Charles Kaiser

The University of Wisconsin Press
Terrace Books

The University of Wisconsin Press

1930 Monroe Street

Madison, Wisconsin 53711

www.wisc.edu/wisconsinpress/

3 Henrietta Street

London WC2E 8LU, England

1 3 5 4 2

Printed in the Cananda

Book design by Jane Tenenbaum

Library of Congress Cataloging-in-Publication Data

Atwood, T. (Tom)

Kings in their castles: photographs of queer men at home / Tom Atwood; foreword by Charles Kaiser.

p. cm.

ISBN 0-299-21150-9 (cloth: alk. paper)

1. Gay men—New York (State)—New York—Portraits. 2. Portrait photography—New York (State)—New York. 3. Photography of interiors—New York (State)—New York. 4. City and town life—New York (State)—New York—Pictorial works. I. Title.

TR681.H65A88 2005
779'.930676'62097471—dc22 2005005439

Terrace Books, a division of the University of Wisconsin Press, takes its name from the Memorial Union Terrace, located at the University of Wisconsin–Madison. Since its inception in 1907, the Wisconsin Union has provided a venue for students, faculty, staff, and alumni to debate art, music, politics, and the issues of the day. It is a place where theater, music, drama, dance, outdoor activities, and major speakers are made available to the campus and the community. To learn more about the Union, visit www.union.wisc.edu.

DEDICATED TO MY FAMILY

CONTENTS

FOREWORD

CHARLES KAISER

What gay men do best is to create beauty. We know that from the melodies of Leonard Bernstein's songs, the shape of Michael Cunningham's sentences, the movements of Jerome Robbins' ballets, the cadences of John Ashbery's poetry, and the courage of Paul Cadmus' paintings.

The eagerness of our embrace of the beautiful is one of the splendid things that set us apart. To be gay is to be different; the enlightened among us recognize from an early age that this is an advantage, rather than a jinx.

Tom Atwood's odyssey toward artistry (and difference) started when he was five years old, when he began visiting his relatives in Manhattan. It was love at first sight. Atwood's infatuation with the greatest of all gay metropolises has only deepened with age. When he moved there in his twenties, he "instantly felt at home. It's a part of me, and it always will be."

This superb collection of photographs is the fruit of that lifelong love affair, a vivid exploration of the gay heart of New York. One of the things that makes Atwood's approach to his subject so unusual is his conviction that gay men are actually more interesting with their clothes on, ensconced in their own carefully constructed spaces. His journey toward photography developed out of a confluence of other interests, including painting, architecture, musical theater, and psychology. The result is the most rounded photographic record we have ever had of the gay urban experience.

This book should find a special place on the list of all the inventions that have long drawn gay men from the heartland into New York—everything from the rhythms of *West Side Story* to the short stories of the *New Yorker,* the epiphanies of *Breakfast at Tiffany's,* and the plots of Edmund White. These pictures encapsulate all the possibilities of Manhattan living. They suggest, correctly, that gay men with ambition are more likely than the average New Yorker to have apartments with high ceilings, curving balconies and spectacular views. Their restless search for beauty has been incorporated into their daily lives. Implicit here are all the gifts that big-city living can bestow, including privacy, eccentric company, and, most importantly, the freedom to create.

Atwood's open personality and his almost courtly approach to his subjects invariably sets them at ease; then he puts them to work. That can be especially difficult when he encounters someone like Pascal Arnaud on September 11, gazing at the incinerated towers of the World Trade Center, but even that catastrophe is incorporated into the artist's vision of the invincible city.

He is a full-service impresario, offering his subjects make up and styling—and doing all of it himself. Atwood sometimes assembles his shots: he believes he has just as much right to arrange his subjects as a painter or a sculptor. The point of his work is not to imitate life, but to clarify it, by making it more vivid. With very little distance between his own life and his photography, his ideas bubble up from his subconscious, offering him directions but no conclusions.

His pictures are a balance of formal grace and spontaneity. Look at the gaze of Michael Cunningham's psychiatrist boyfriend, suggesting an Indian scout still deciphering the personality of his longtime companion, or Chris Beane reveling in a little role-reversal, striking a pose for a fellow photographer. Tim Bellavia offers an improbably seductive embrace of a Singer sewing machine, while Hush McDowell playfully mimics the posture of his dog.

Atwood crops his shots as little as possible. He likes strong lighting that produces a heightened, Technicolor effect, striking but never cold. Each picture includes as much of the subject's environment as possible, yet nothing feels crowded or forced. Floors and ceilings (especially the decorated ones) sometimes reveal as much about his subjects as their expressions. Manhattan's azure sky peaks in over many of his subjects, making the city a character in these photographs, and bathing its citizens in its most cheerful light.

While some of these apartments have a spare elegance, most are crammed with objects, like Chuck Hettinger's porcelain poodles (to keep the real one company), Simon Doonan's busts, John Waters' snapshots, Mark Vitulano's crosses, or Tom O'Horgan's musical instruments. Jonathan Katz gazes at reams of gay history, all distilled on thousands of index cards, while Hedda Lettuce holds court beneath a multitude of wigs. In front of someone else's lens, objects like Austin Chinn's pink flamingoes might have suggested clichés, but this photographer's approach makes the final work feel more complex than its parts.

Like many of the artists in this volume, Atwood strives for something polished, graceful and beautiful, always looking for patterns within the chaos of Manhattan. Combining elements of reality and fantasy, he "bears witness to splendor" whenever he can.

Edmund White and his apple are perfectly balanced by bookcases crammed with manuscripts, with coarse white light streaming in behind him from a Chelsea street. Tommy Tune presides over the Manhattan skyline, a sprawling dandy in white. Artists, architects, art dealers, archivists, dance essayists, bankers and writers; White House staffers, store owners, window dressers, movie directors, personal trainers and interior decorators; documentarians, painters, pianists, professors—Atwood has found a way to celebrate them all.

For gay kids everywhere, still longing to learn how to transform their difference into a blessing, the answers are all in these pages.

ACKNOWLEDGMENTS

Special thanks to Raphael Kadushin, Sheila Leary, Sheila Moermond, Alex Sauer, Terry Emmrich, Margaret Walsh, Andrea Christofferson, Kirt Murray, Benson Gardner, Erin Holman, Tina Marie Maes, Kara Zavada, Jamie Birkett and others from the Press.

Gratitude to all those who were generous enough to provide access to their lives and homes, including David Steward, Carson Kressley, Hal Bromm, Bill Stevenson, Michael Scheible, Leonard Finger, Michael Denneny, Robby Browne, Bruce Bierman and William Secord, Richard Kromka, David Schorr, John Hunter, Mark Beard, Barton Benes, Mark Darrel, Robert Burnside, Edward Field, Paul Kennedy, J. D. McClatchy, Chip Kidd, Bill Sullivan, Jaime Manrique, Charles Nolan and Andy Tobias, Alfrado Paredes, Tobias Schneebaum, and others.

Additional thanks to Johnnie Moore and Ashton Hawkins, Kevin West, Armistead Maupin, Stuart Elliott, Leta Ming, Tony Kushner, Brian Ellner, David Mehnert, Larry Kramer, Peter Vissers, David Sedaris, Charles Kaiser, Ted Allen, Dr. Robert Brown, Susan Meiselas, Curtice Taylor, Burt Levitch, Ed Robinson, Jeff Sheng, Amy Sohn, David Gold, Brian Clamp, Charles Busch, Kevin Jennings, Jann Wenner, Barbara Seyda, Philip Johnson, Oliver Luckett, Jonathan Rotenberg, David Easton, Troy Roberts, Jeffrey Bilhuber, Jay Janus, Andy Towle, Dominick Dunne, Arly Kjellstad, Scott Ehrlich, Bob Mack, Jasper Johns, John Crocker, Andre Leon Talley, Eck Neng Goh, John Furth, Tom Bianchi, Bradford Smith, Marc Jacobs, Jesus Escobar and Eric Lee, Adam Williams, Ryan Leaderman, Brickson Diamond, David Rosen, Jeff Wolk, Jared Hohlt, Bret Easton Ellis, Thomas Queen, Mark Newhouse, Christopher Ciccone, Brian Cummings, Brad Gooch, Elliot Andrews, David Cooley, Don Weinstein, Ken Green, Antony Todd, Greg Drew, Stephen Sondheim, Tom de Vries, Brad Schmidt, Andrew Sullivan, Sarah Fitzharding, Gore Vidal, Bobbi Lane, Lady Bunny (Lypsynka), Kevin Merrill, Ellsworth Kelly, Cat Corman, Walter Schubert, Bruce Richman, Nick Street, Mikel Wadewitz, Greg Morey, Ted Gideonse, Madelyn Postman, Jennie Dunham, Richard Socarides, Joanna Hurley, Brian Offutt, Catheryn Johnson, John Berendt, David Leavitt, Henrik Harpsoe, Jim Sherman, and Jeff Soref.

Much appreciation for the financial support of the de la Torre Design Studio and Heather and Richard Forrest.

ARTIST'S STATEMENT

Gay men take great pride in cities. We congregate in the most beautiful cities—New York, San Francisco, Sydney, and Amsterdam. We would gladly trade half of even the smallest apartments to live in more interesting neighborhoods. And it is no secret that we are urban pioneers, the first to appreciate undiscovered neighborhoods. Our arrival often precedes a wave of cafés, bookstores, galleries, and, in time, straight style-watchers.

Similarly, we take great pride in our living spaces. With a flair for design, we craft playful, often outlandish homes. Our apartments follow fashion—brushed steel instead of marble, Neopolitan martinis in lieu of beer—and flee from it, with gaudy antiques balancing disposable kitsch. For a community that is obsessed with image and beauty, our living spaces are the ultimate in self-expression. The gay man's home is a metaphysical extension of himself.

There is a profound need for a photo documentary of the gay male community that downplays flesh and zeroes in on the complicated, multidimensional personalities of its members. Given how urban and urbane we are, why is it that most gay photography books depict nudes in the wilderness or on the beach? *Kings in Their Castles* responds to this need by documenting gay men at home in New York. In this first in a projected series of books, I offer a window into the lives and apartments of some of the most intriguing personalities in the city. Alongside the bankers, media professionals, and architects, I document a breed of urban bohemians, beatniks, mavericks, and iconoclasts that seems to be slowly disappearing. Greater acceptance and assimilation, while clearly a desired shift, entails its own kind of loss.

The personalities and interiors of *Kings in Their Castles* lend themselves well to color portrayal, and so I describe them with the full color palate. My intention is to produce fine art prints rich in beauty and clarity. But I attempt to distinguish *Kings in Their Castles* from other photography series in a number of aspects. I often seek out apartments packed with wall-to-wall belongings, paraphernalia, and detail. I attempt to suggest what such spaces reveal about the range of gay New Yorkers' personalities as well as how complex our personalities can be. Similarly, to illustrate that subjects and environments are a unified fabric—that gay men construct self-images through decorating—I choose a wide depth of field. Neither subject nor apartment predominates; my images are an attempt to balance the two. Conventional portraiture, on the other hand, tends to emphasize the person, through backgrounds of streamlined simplicity often with a narrow depth of field.

To fully create 360-degree portraits, I attempt to photograph people in daily activity—modern-day *tableaux vivants*.

I seek out whimsical, intimate moments of daily life with subjects unaware of the camera. I strive for photographs that shift between the pictorial and the theatrical and that have elements of both formal portraiture and informal snapshots. I disclose, however, that many of my shots are staged. Just as an artist has free reign over his canvas or a playwright dictates the set and blocking on her stage, I suggest poses and occasionally rearrange subject matter, as long as such adjustments reflect reality and remain true to the way that subjects live in their apartments.

Finding and photographing individuals for *Kings in Their Castles* became a psychological addiction of mine for four years—something that I felt compelled to find time for despite a busy work schedule. Most subjects came through referrals from friends or friends of friends. Yet some of the most interesting subjects emerged from some of the most unlikely sources: an elderly woman next to me on a plane, a don from Cambridge University, an Afrikaner management consultant, an LA high school student, a magazine editor from a dinner party in Paris and a government bureaucrat in Amsterdam who had never set foot in America.

The subjects in *Kings in Their Castles* are admittedly by no means a representative social or ethnic cross section of gay New York. The book is less a cultural ethnography than a miscellaneous catalogue of personalities and living spaces. Yet the armchair anthropologist in me can't help sharing some broad observations about gay New York. Perhaps as a way to compensate for a society that would like to convince us of our inadequacies, we aspire to be different, larger than life, and to succeed, often immodestly. One of the ways we construct aspirational self-images is through visual accoutrements. This might explain why disproportionate numbers of gay men take an interest in clothes and beautiful living spaces. And as collectors, we are as proud to display the finest Wedgwood as we are our ignoble knick-knacks. It is true: queers have bathroom cabinets stocked with cologne, moisturizers, exfoliants and even mascara. We also collect gaudy Greek statues, Broadway musical paraphernalia and CDs of Cher.

Many of these observations should be apparent in the images in *Kings in Their Castles*. The photographs act as a catalyst in this self-expression, permitting subjects to be aspirational exhibitionists. Equally telling were some images that unfortunately could not fit in the book: Carson Kressley from *Queer Eye for the Straight Guy*, sitting on his toilet; restaurant owner Florent, framed by walls scribbled with Keith Haring graffiti remaining from a party; cannibal Tobias Schneebaum, organizing human skulls amongst a jungle of plants; Alan Rohwer, public relations consultant for Versace and Madonna, sifting through the world's largest collection of Madonna magazine covers; Christie's creative director Ray Kurdziel, lounging in an impeccably tasteful parlor; John Waters sifting through old movie props in his attic, adjacent to his terrorist anthrax art installation; Charles Nolan and Andy Tobias, treasurer of the Democratic National Committee, drinking by their Christmas tree; *Yale Review* editor J. D. McClatchy, beside his towering two-story bookshelves; Todd Oldham pinning chromolithographs of moles on a painting of an old white man; and female impersonator Tish, videotaping passersby. Others sadly missing are subjects for whom

scheduling proved difficult: choreographer Merce Cunningham; CBS reporter Troy Roberts; Randy Jones, the cowboy from the Village People; poet Edward Field; writer Terrence McNally; and *Vogue* editor Hamish Bowles.

Collectively, the subjects, expressions, and interiors that comprise *Kings in Their Castles* constitute an autobiography of sorts. They represent thoughts I've wanted to write, images I've wanted to paint, and individuals I'm delighted to count as part of my life. I hope that you find the sum of these photographs both powerful and beautiful and that they arouse in you as much delight and curiosity as they do in me. You may view additional photographs at www.TomAtwood.com.

KINGS in Their CASTLES

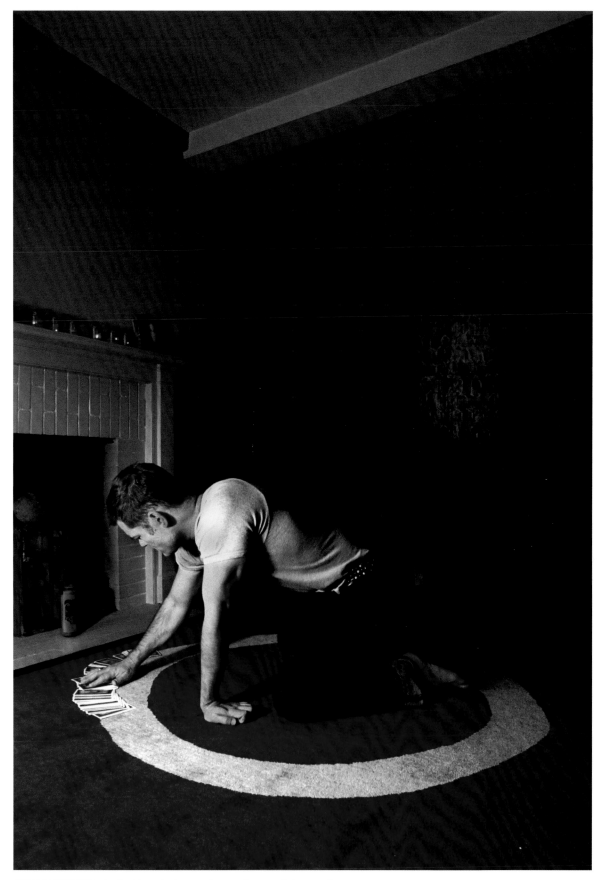

JOHN BARTLETT | fashion designer | reading medicine cards

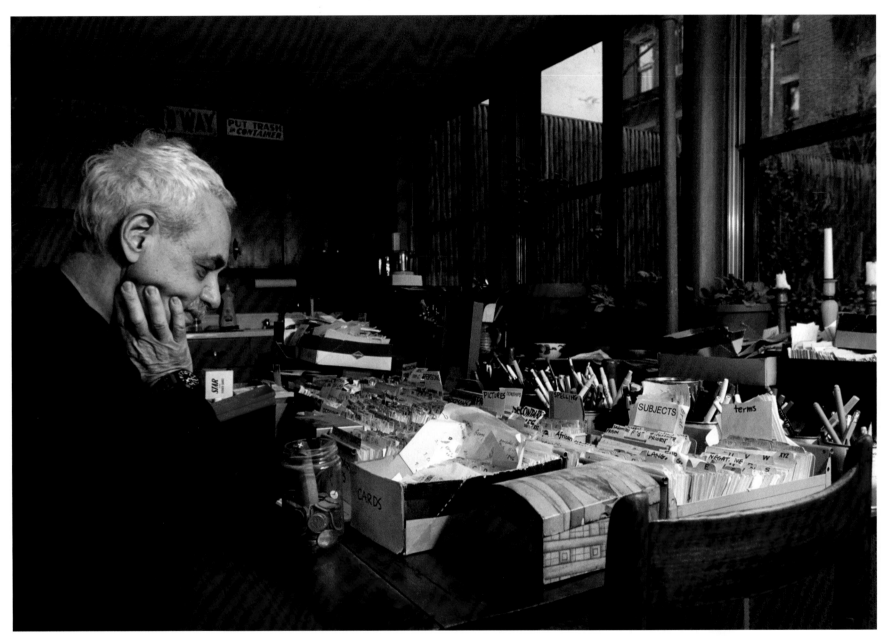

JONATHAN KATZ | historian | cataloguing gay references throughout history

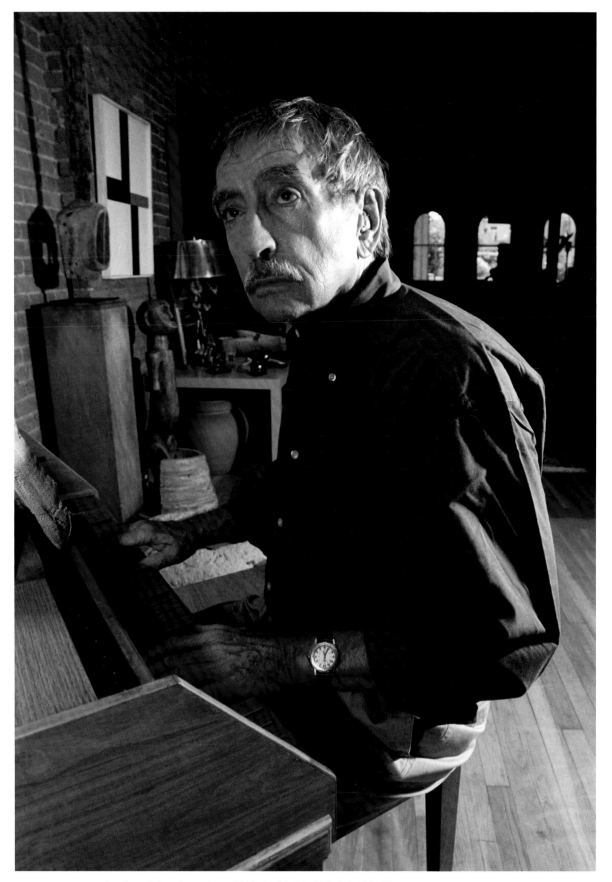

EDWARD ALBEE | playwright | author of *Who's Afraid of Virginia Woolf?*

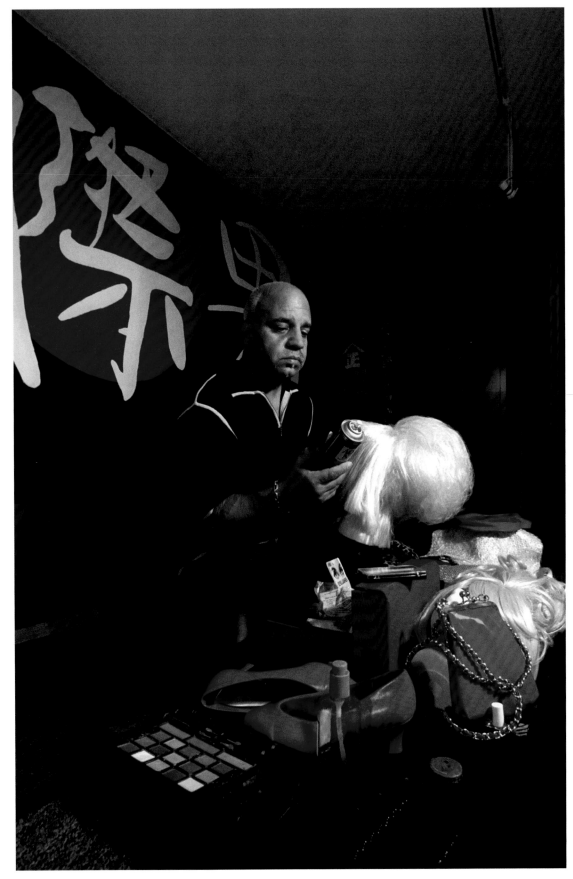

JOHN SCOLARO | blood banker | about to dress in drag

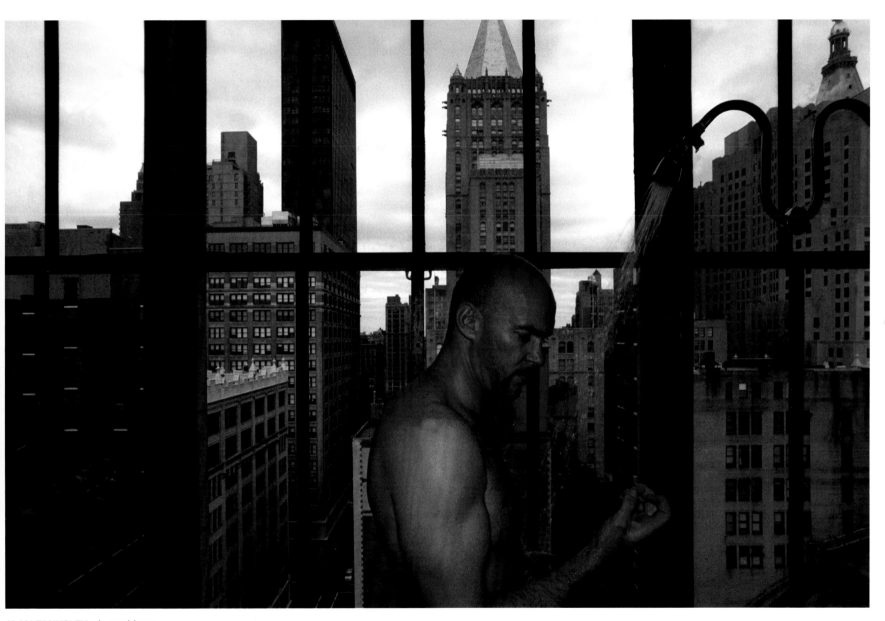

ALAN TANKSLEY | architect

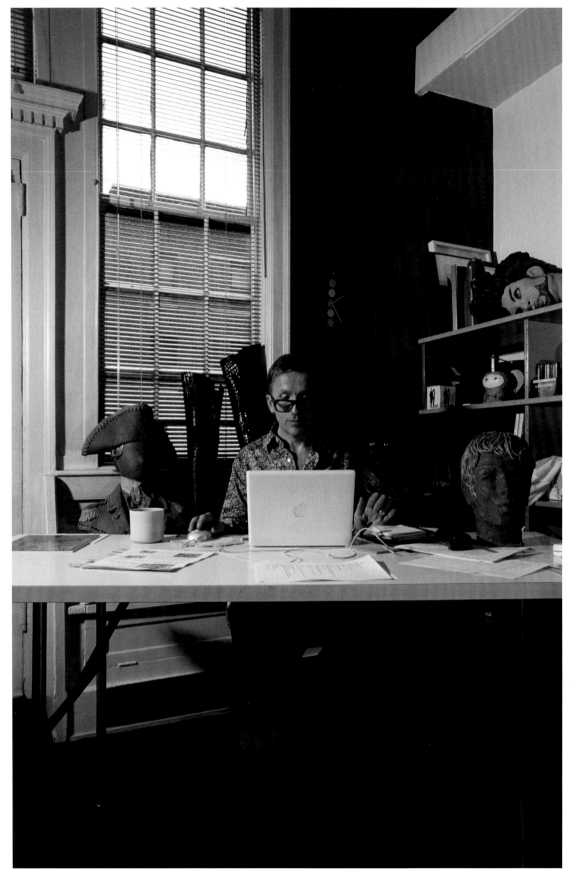

SIMON DOONAN | creative director of Barney's New York

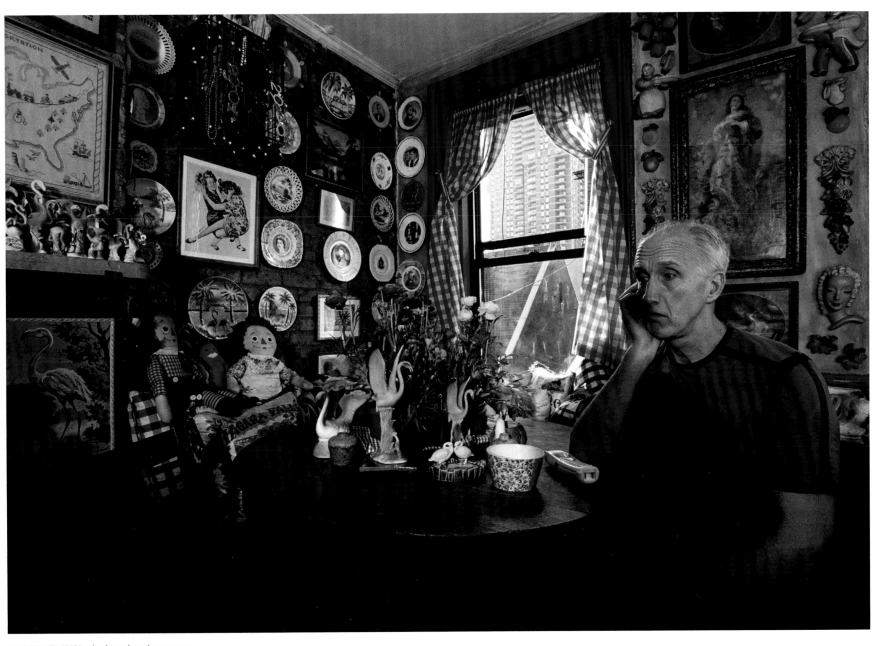

AUSTIN CHINN | interior decorator

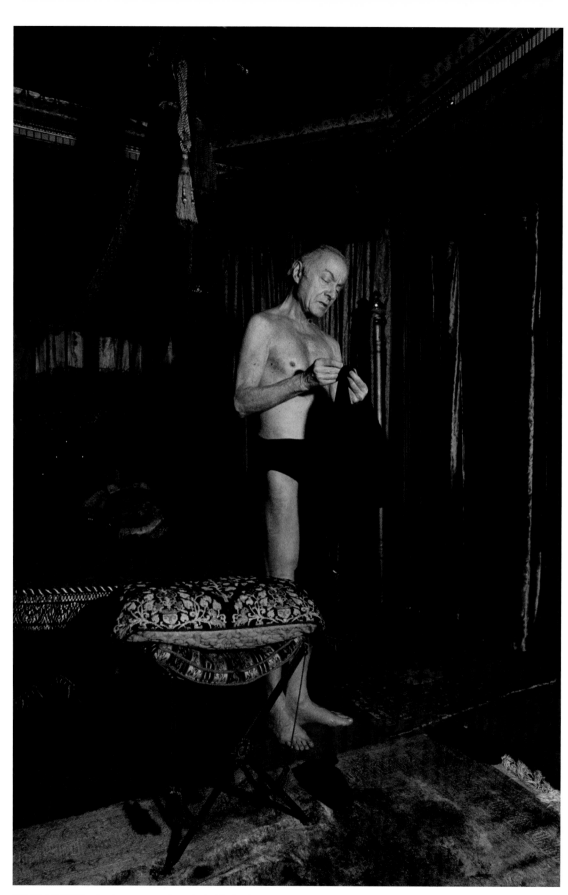

DAVID LERNER | dance essayist | in his bedroom

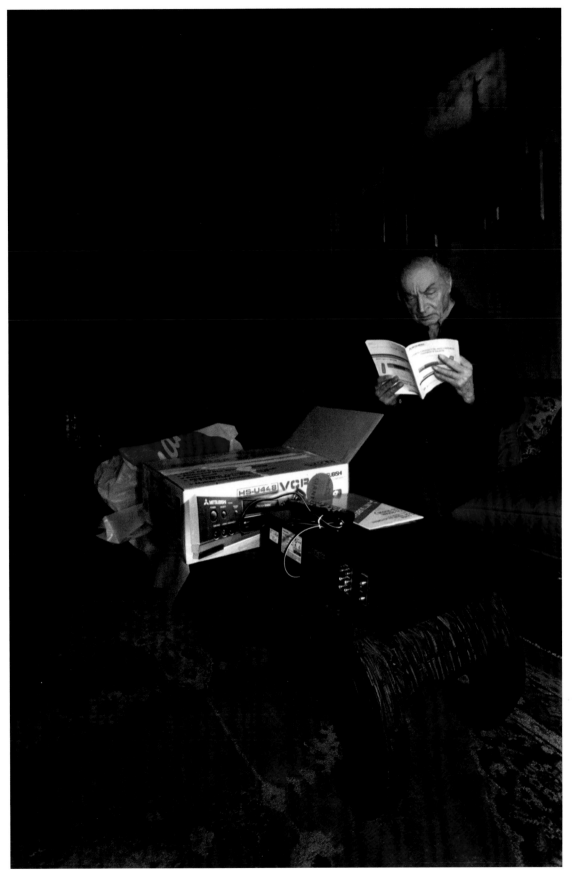

learning how to install a VCR

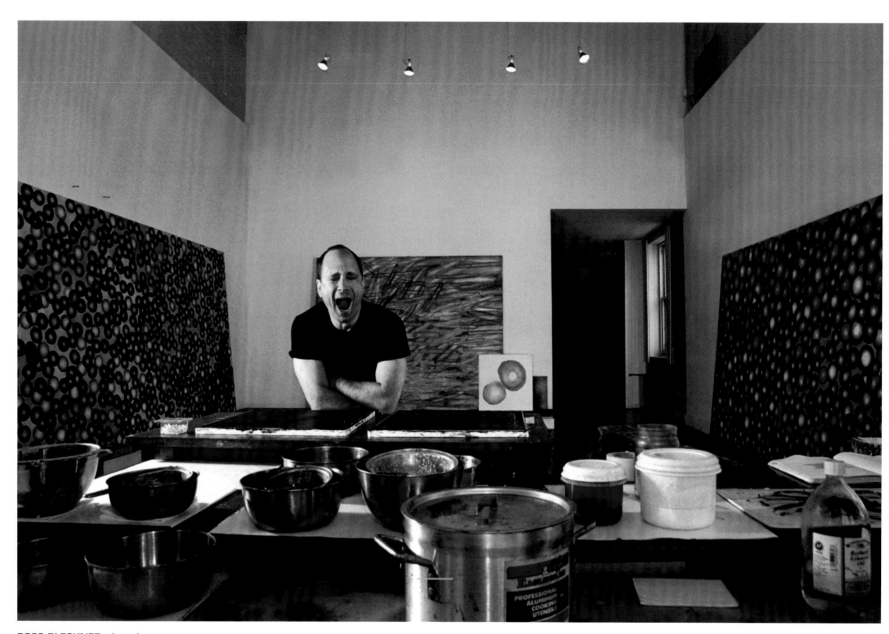

ROSS BLECKNER | *painter*

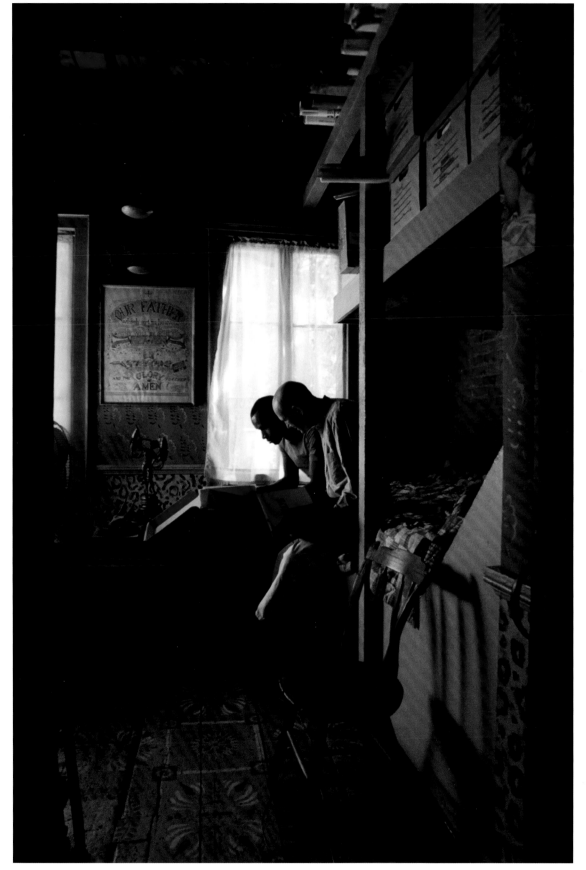

SUR RODNEY SUR | archivist | **GEOFF HENDRICKS** | artist | perusing childhood mementos

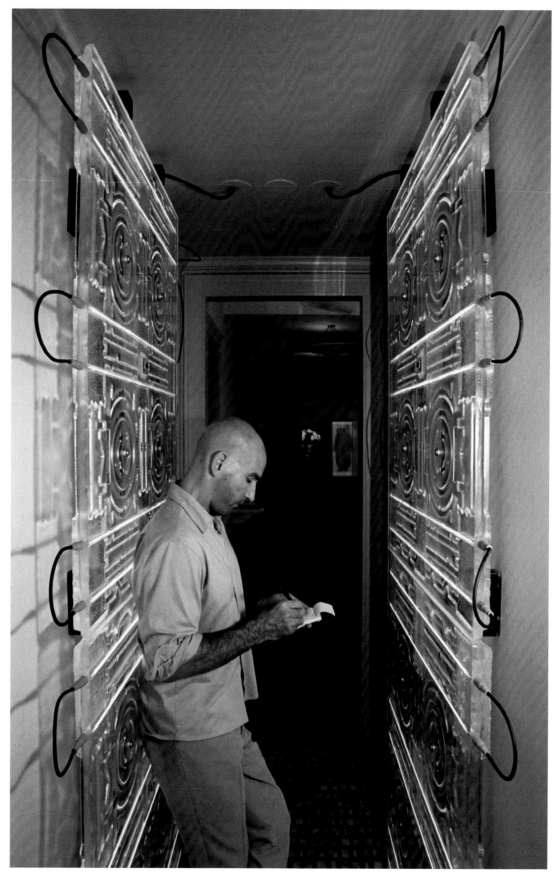

TOM HEALY | art dealer

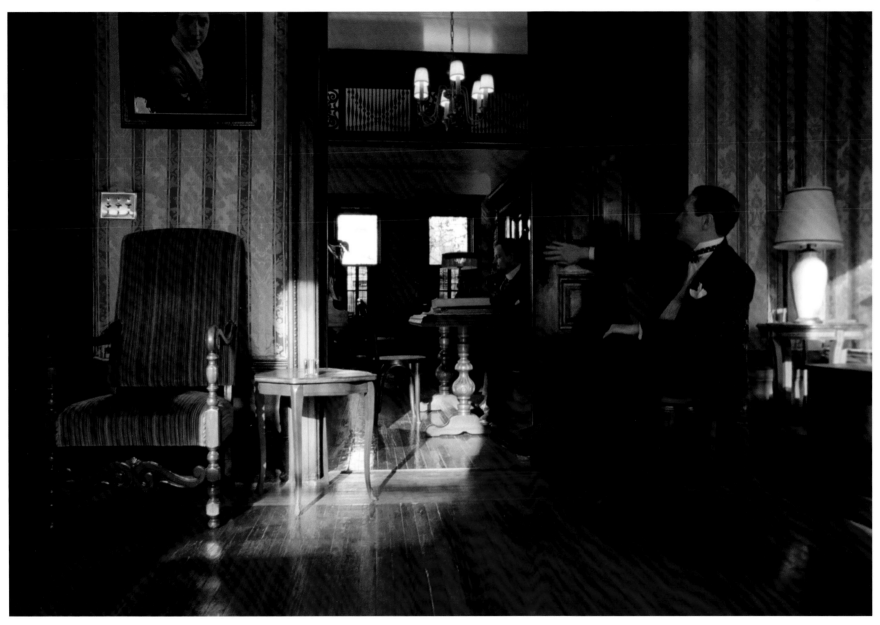

ERIC BERNHOFT | documentarian | **PETER MINTUN** | pianist | waiting to receive guests

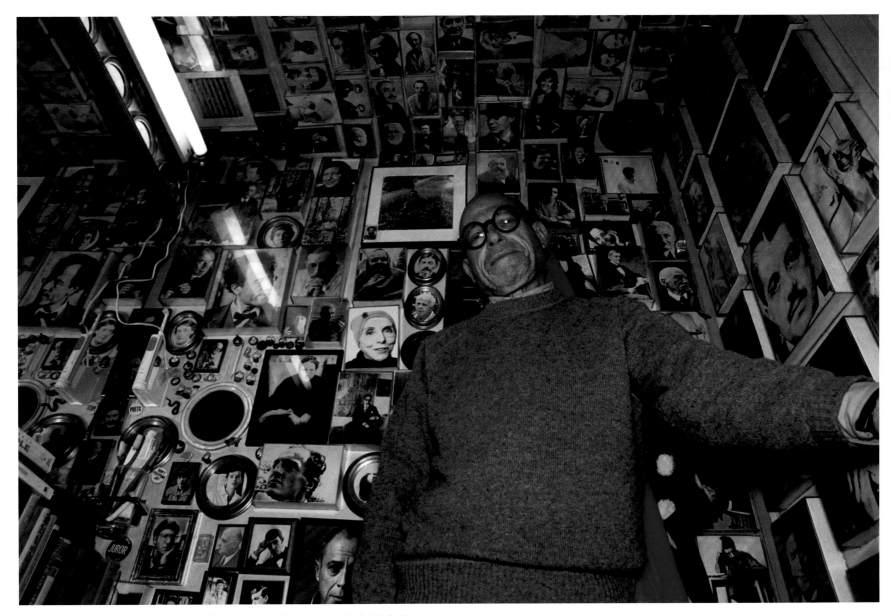

RICHARD HOWARD | Pulitzer Prize–winning poet and translator | in his bathroom

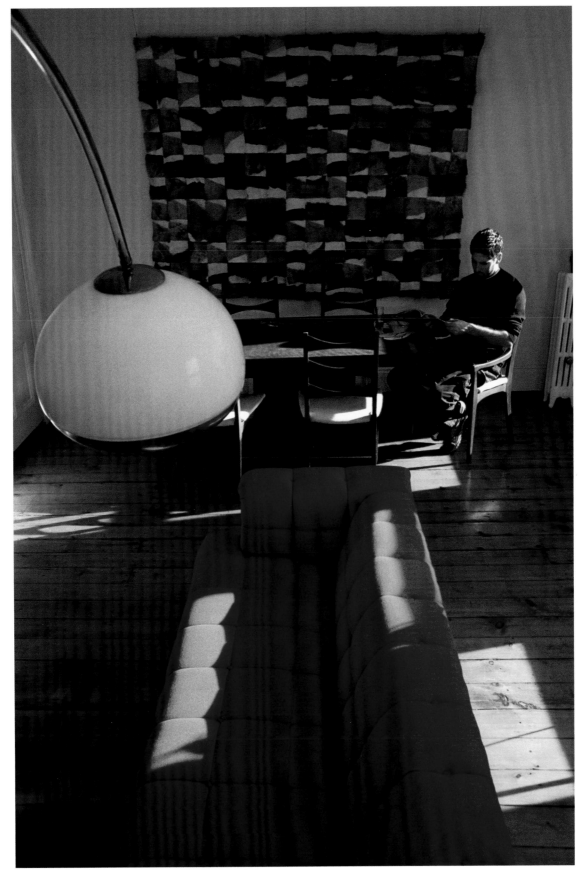

JAMES DALE | Boy Scout plaintiff

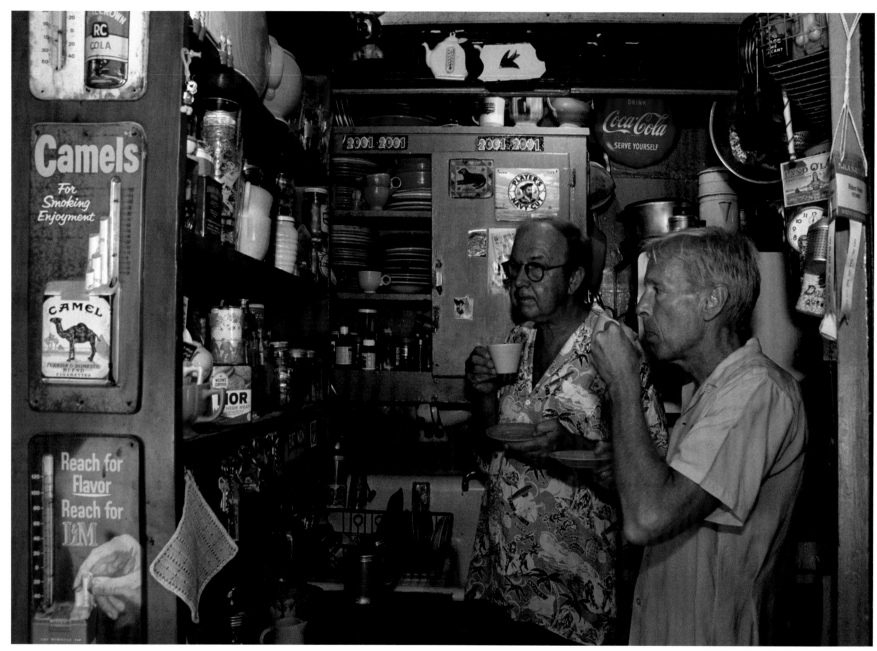

ROBERT HEIDE | playwright | **JOHN GILMAN** | writer

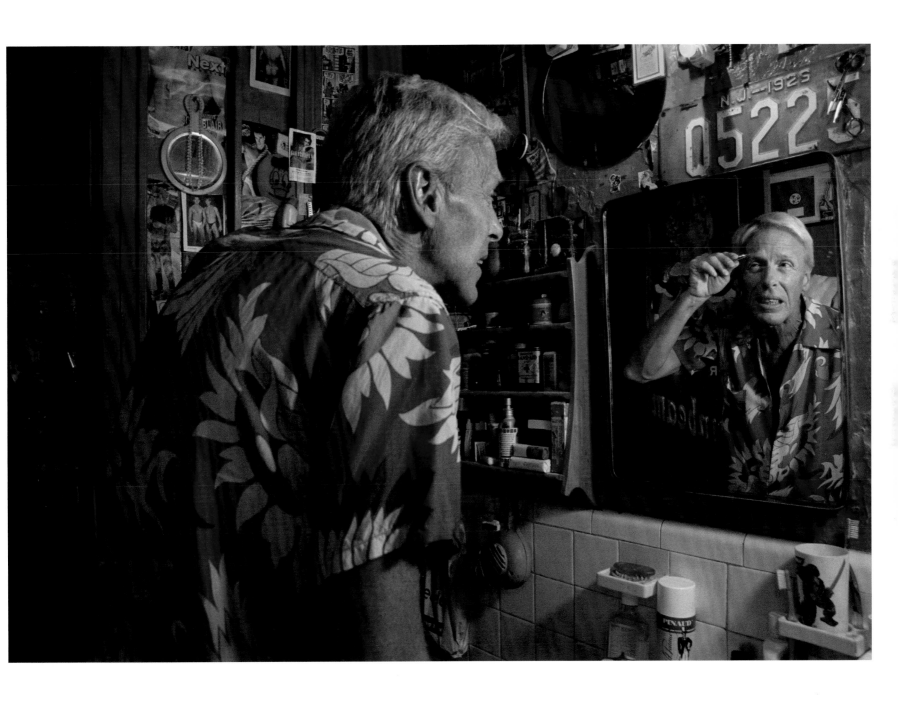

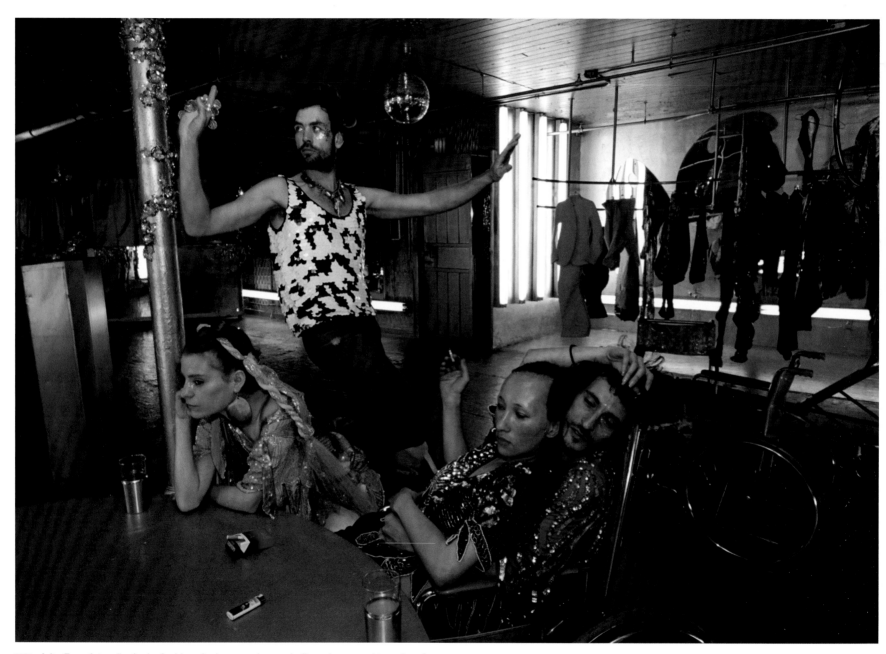

KAI of As Four (standing) | fashion designers who work, live, sleep, and travel as four

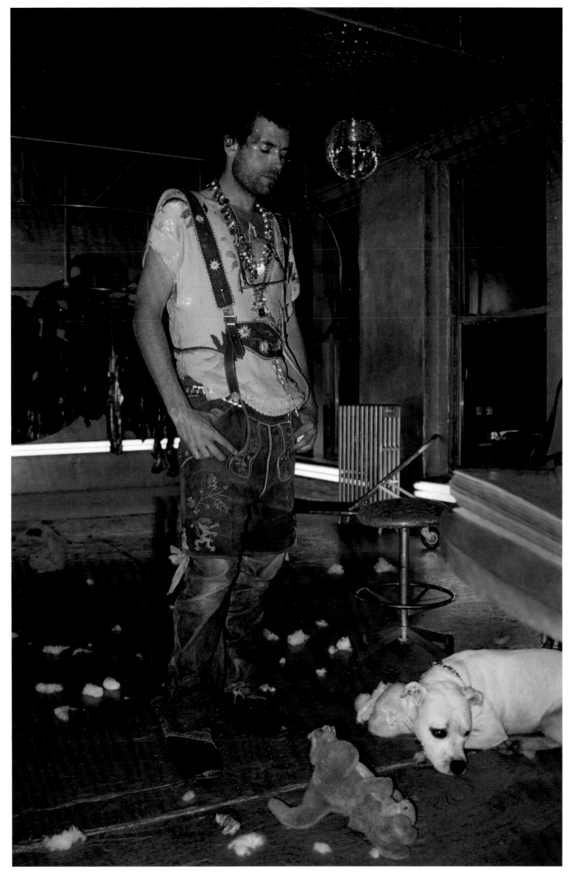

with his dog's mess

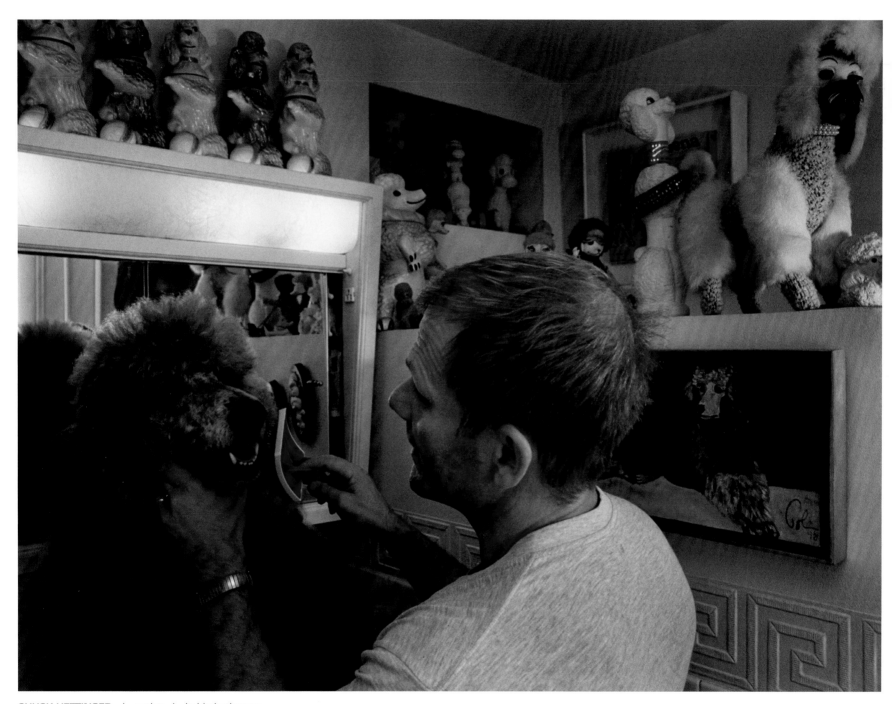

CHUCK HETTINGER | artist | in his bathroom

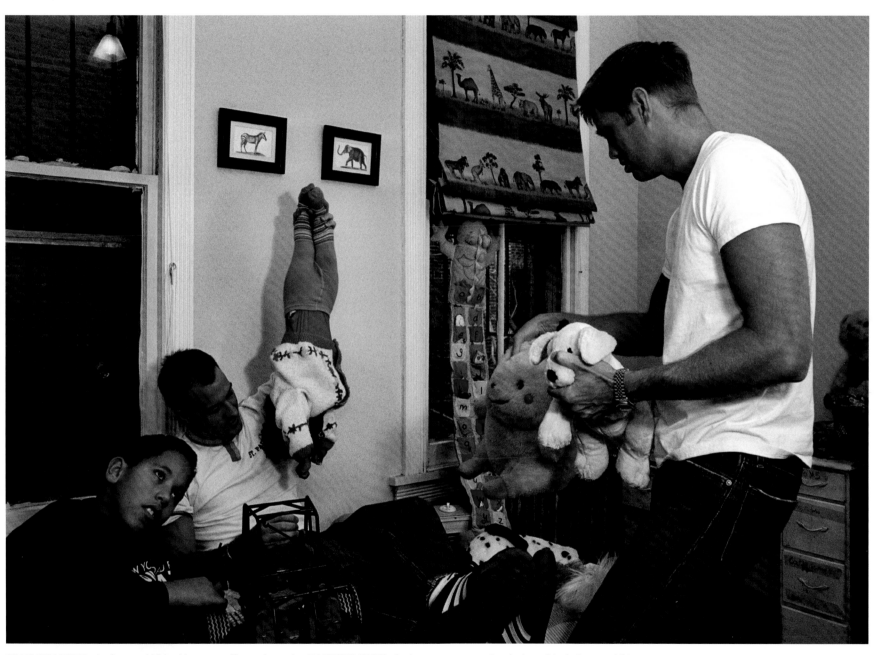

SEAN MALONEY | former White House staff member | **RANDY FLORKE** | home restorer | playing with their two children

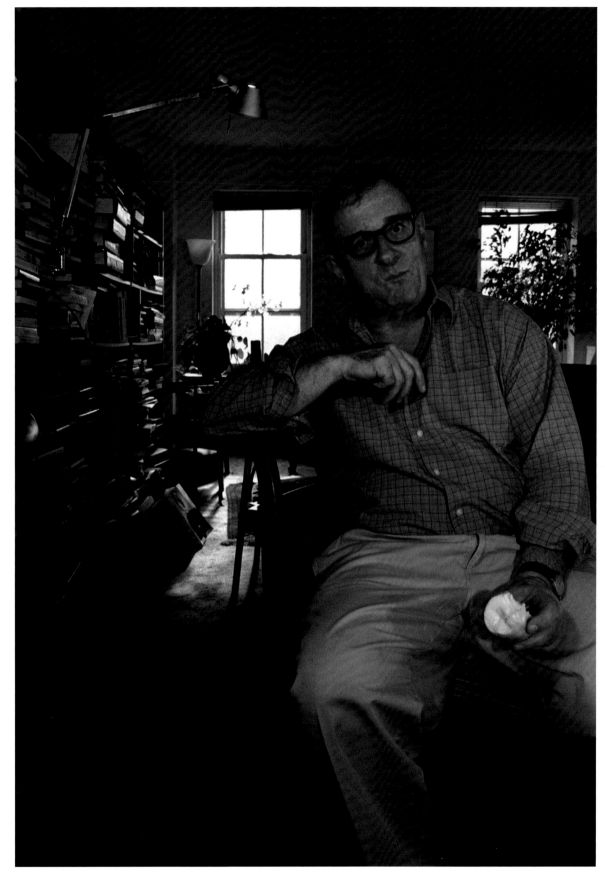

EDMUND WHITE | author of *A Boy's Own Story*

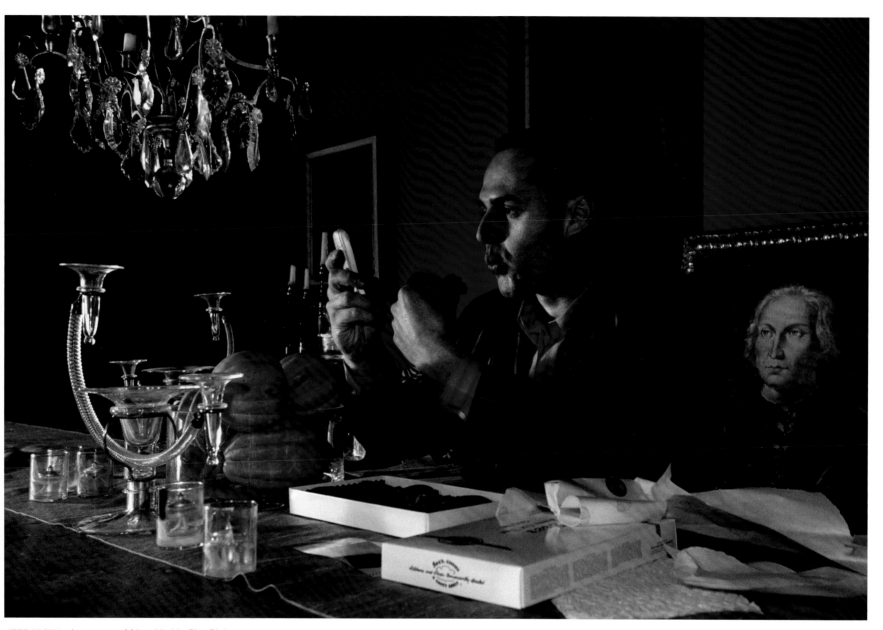

JEFF KLEIN | owner of New York's City Club

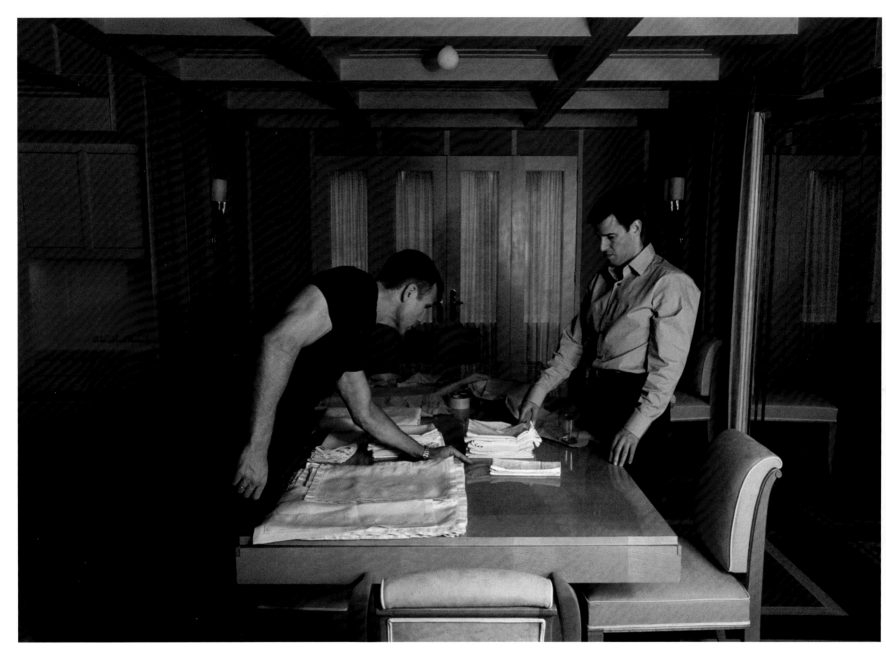

MATI WEIDERPASS | personal trainer | **IAN REISNER** | investment banker

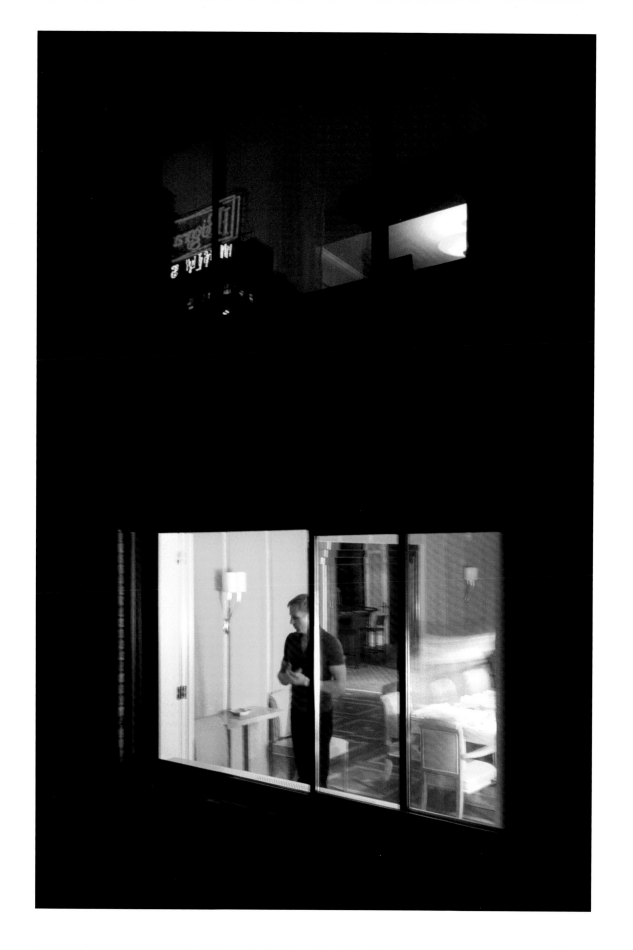

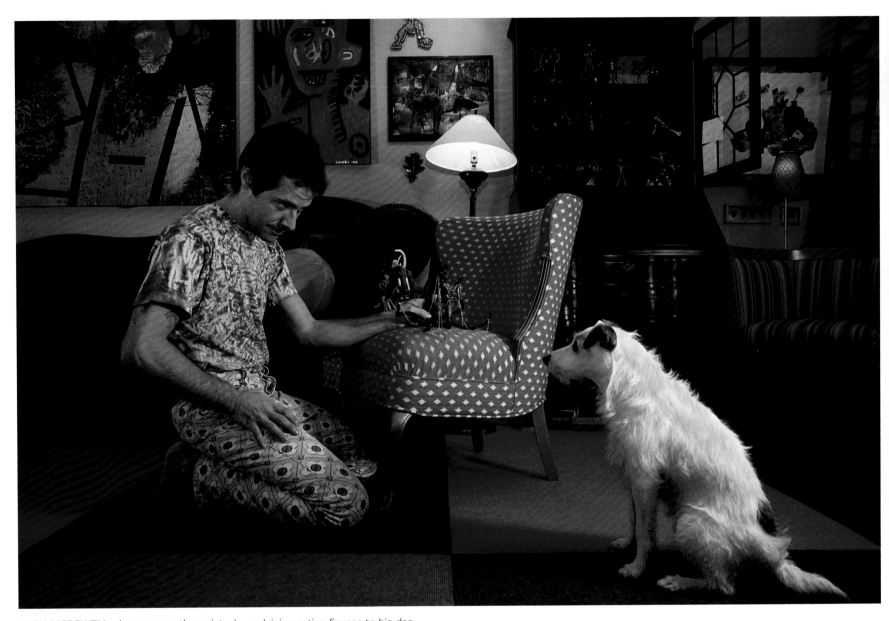

HUSH MCDOWELL | massage therapist | explaining action figures to his dog

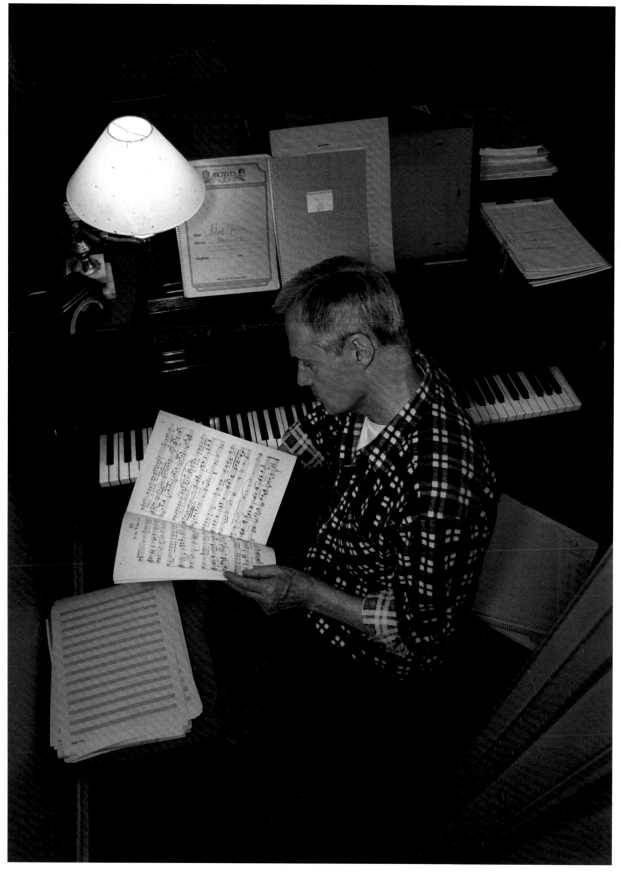

NED ROREM | composer and author of *The Paris Diary*

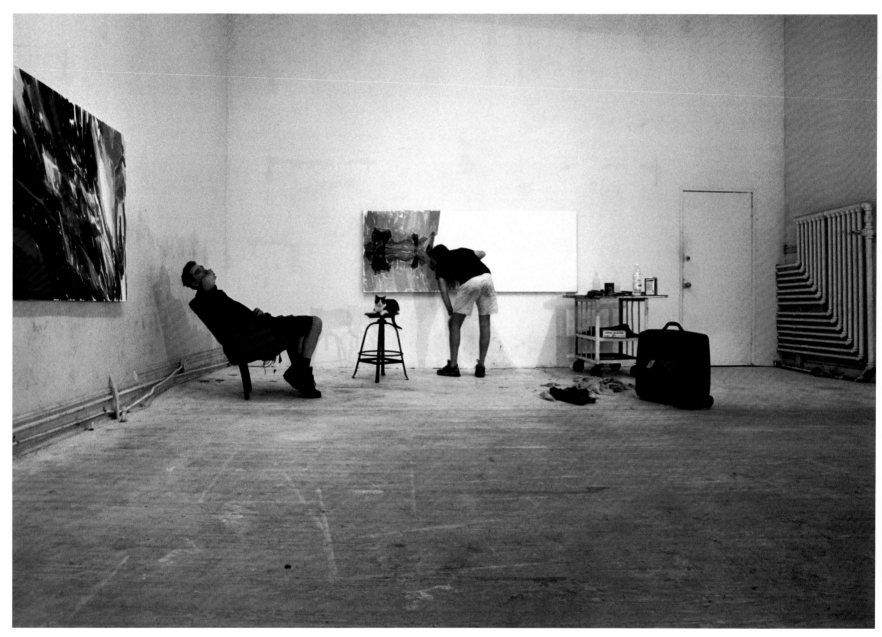

OLIVER HERRING and **PETER KRASHES** | artists | in their home studio

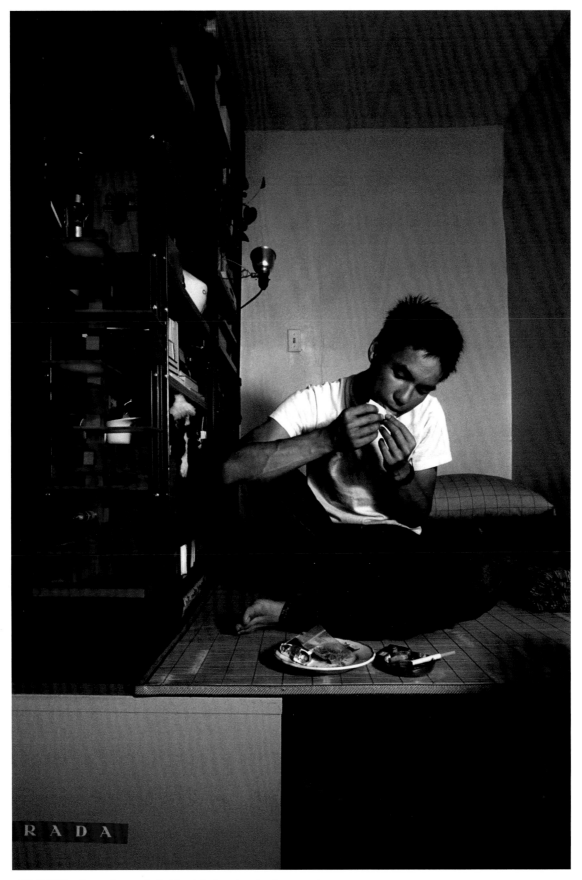

TOBI WONG | sculptor | in his eight-foot by nine-foot apartment

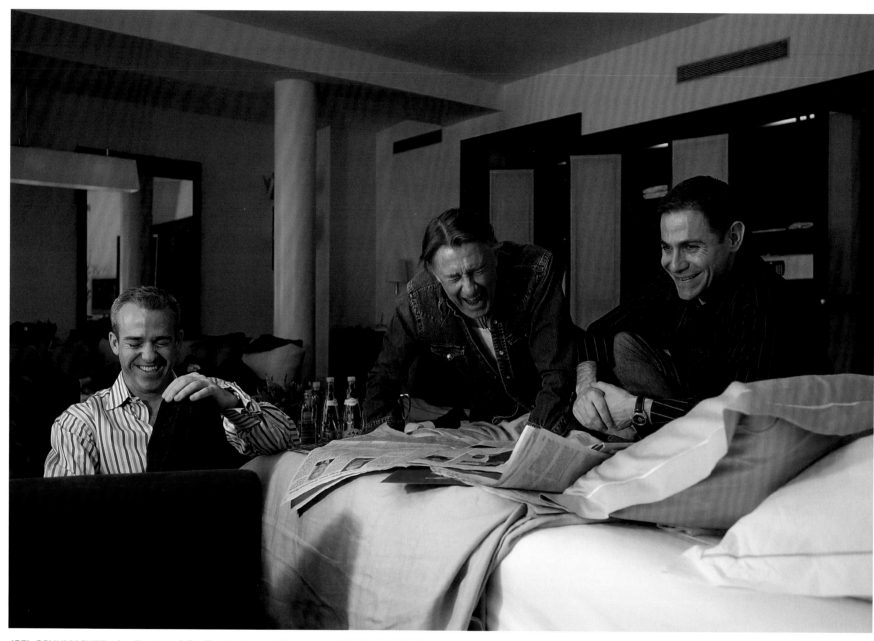

JOEL SCHUMACHER | director of *St. Elmo's Fire* and *Batman and Robin* | with friends **JESS CAGLE** (left) | *People Magazine* senior editor |
STEPHEN FRIEDMAN (right) | MTV executive

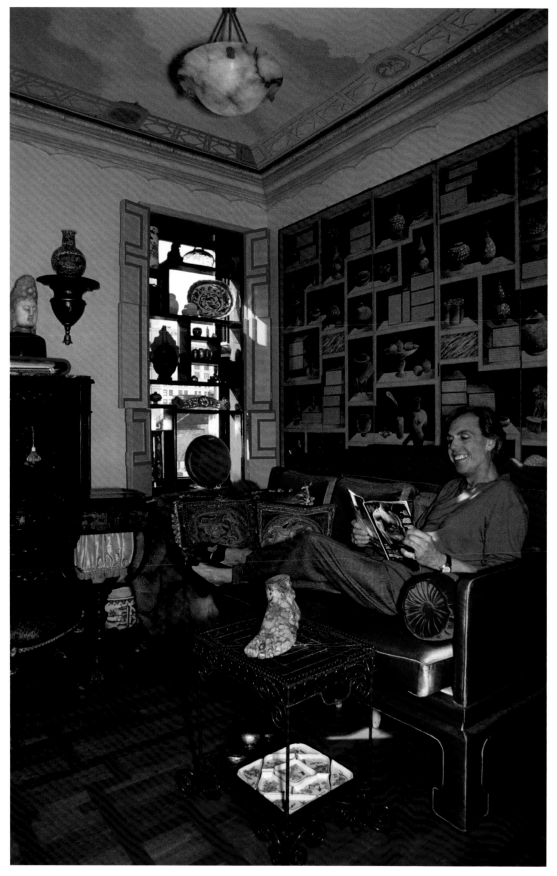

GARY TISDALE-WOODS | community volunteer

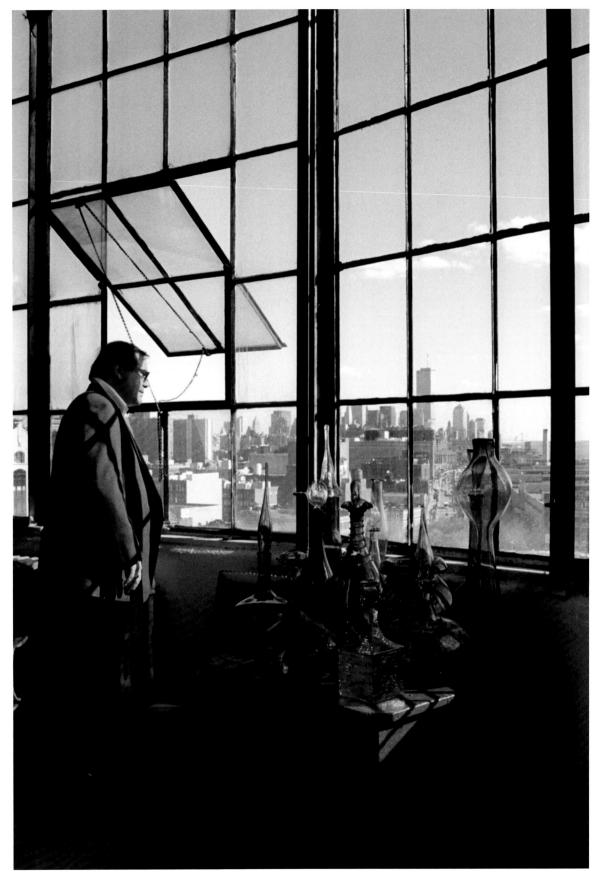

HUNT SLONEM | artist | in his purple room

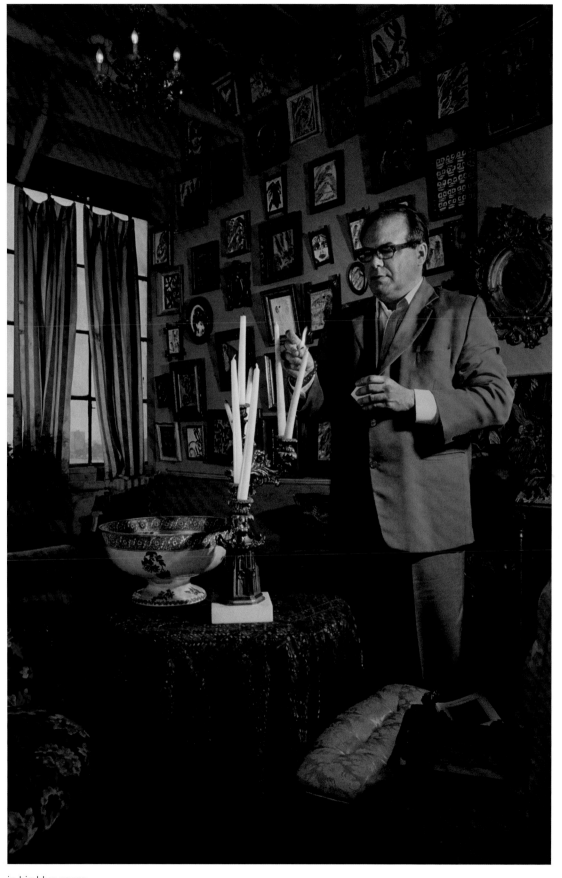

in his blue room

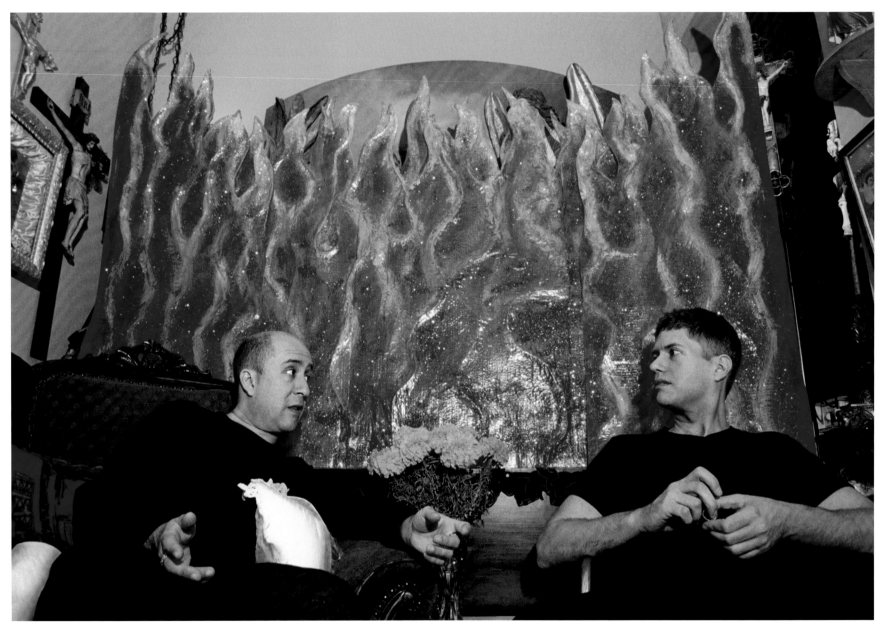

GLEN SANTIAGO | performer | **JOHN HOGE** | programmer | in front of their Day of the Dead shrine

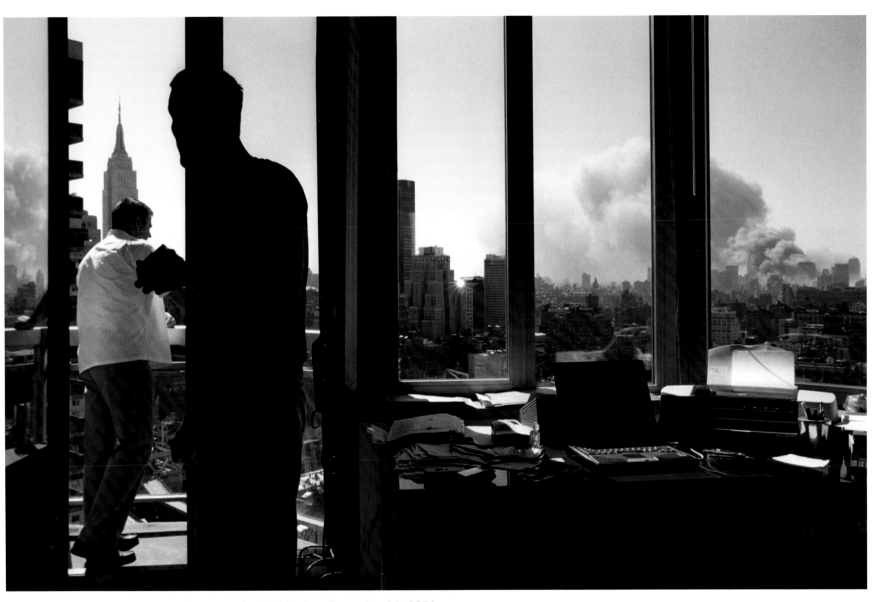

PASCAL ARNAUD (silhouette) | store owner | with friend, on September 11, 2001

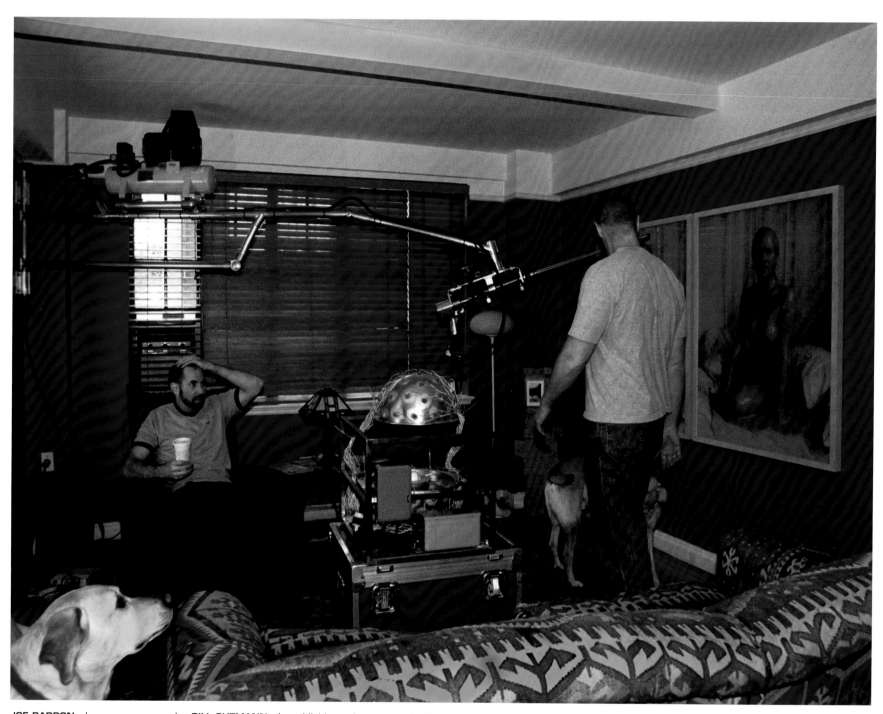

JOE BARRON | gym manager | **BILL GUTMANN** | publishing salesperson | discussing the nuclear bomb in their living room

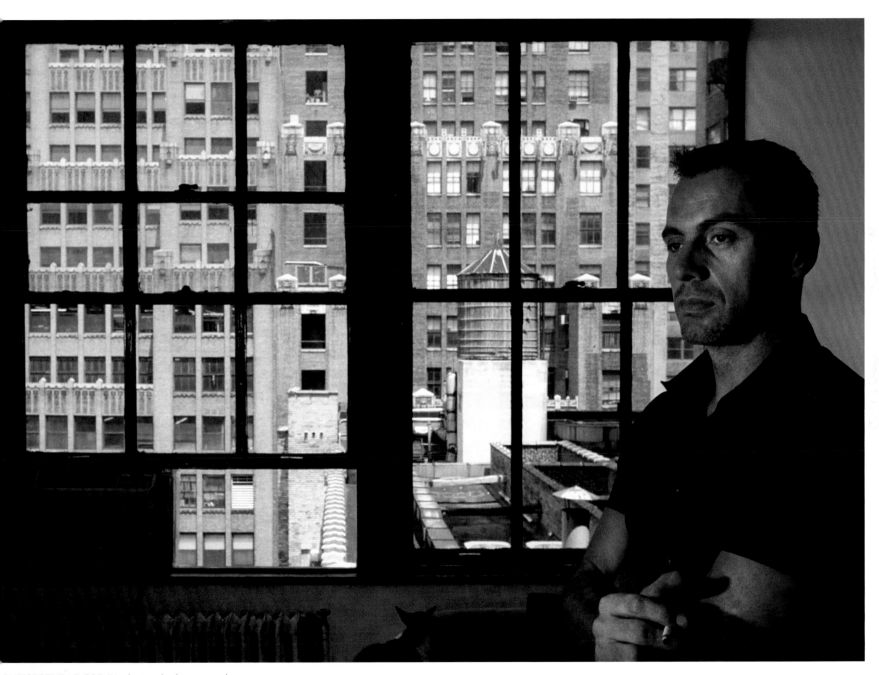

CHRISTOPHE LE GORJU | marketing executive

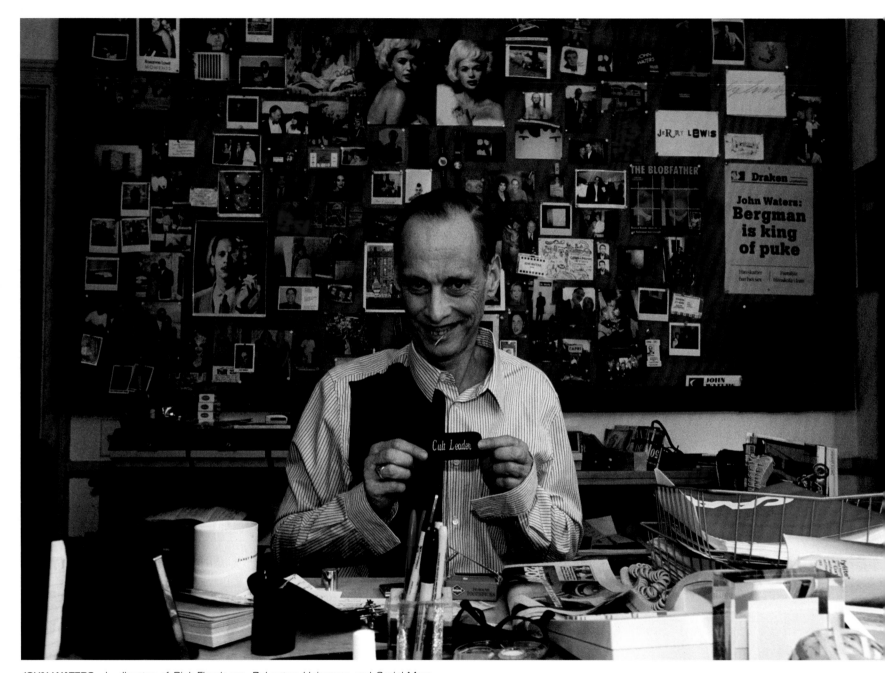

JOHN WATERS | director of *Pink Flamingos, Polyester, Hairspray,* and *Serial Mom*

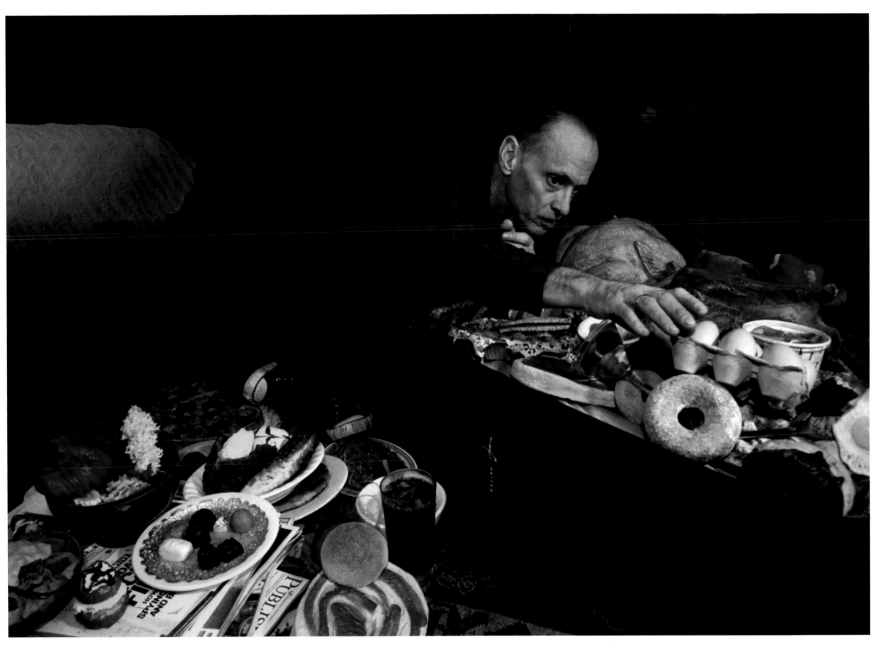

packing his suitcase

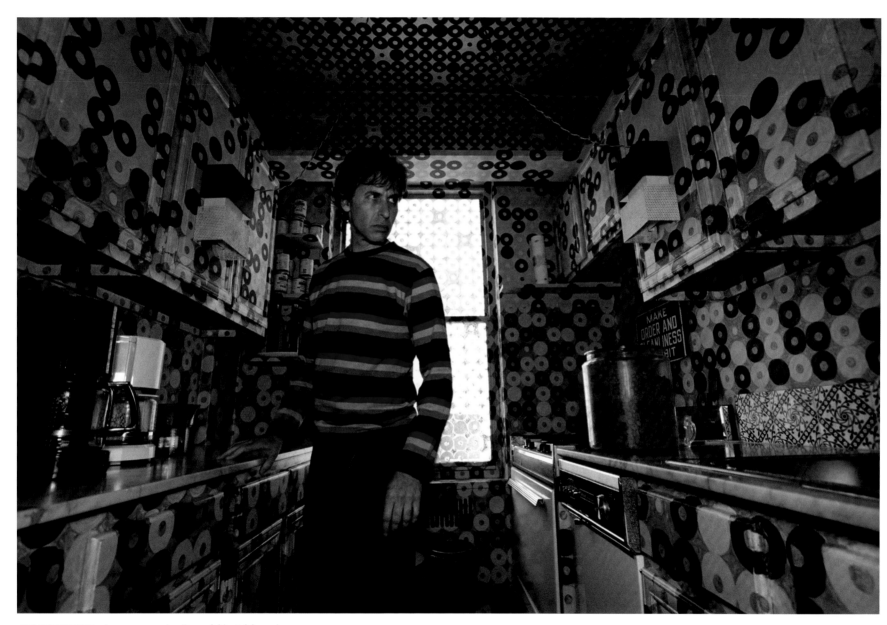

JOE HOLTZMAN | owner and editor of *Nest Magazine*

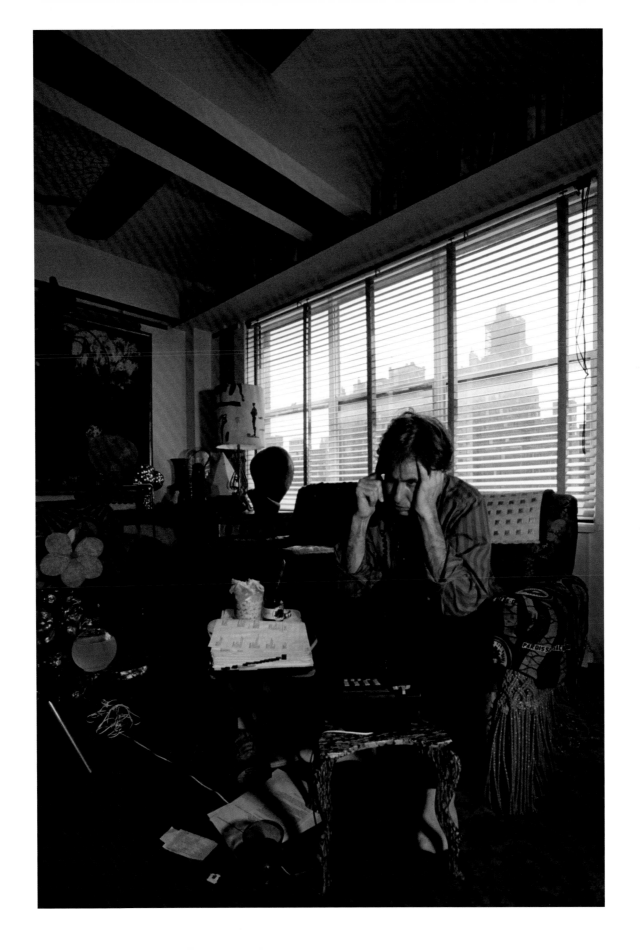

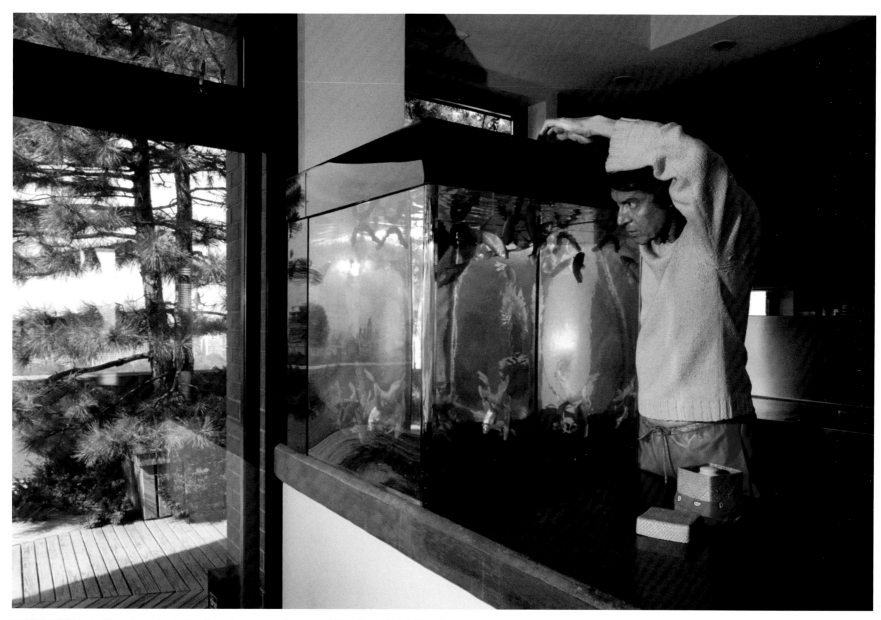

TOMMY TUNE | Tony Award–winning Broadway star, director of *The Best Little Whorehouse in Texas*

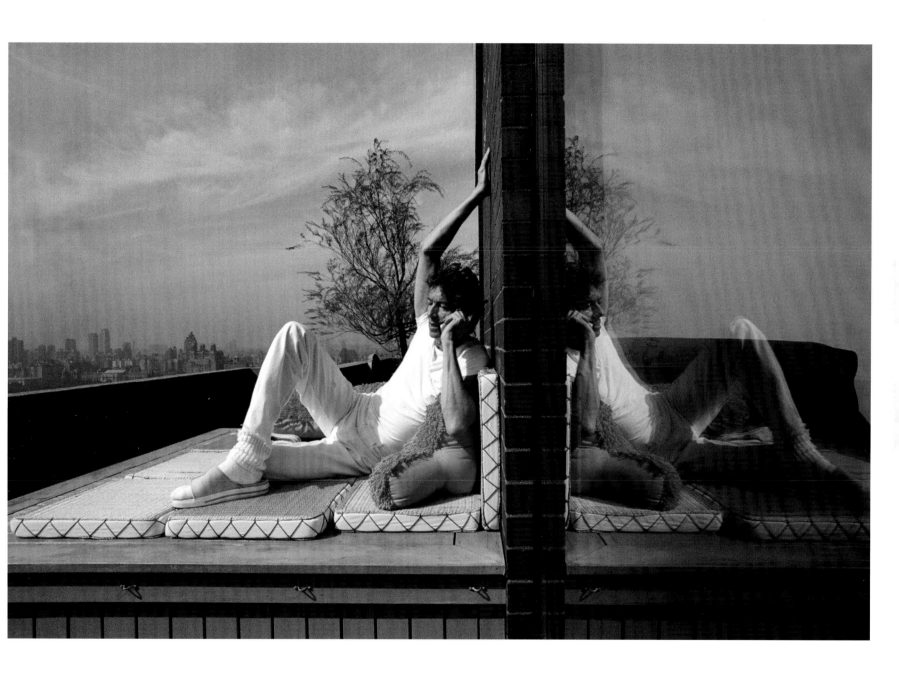

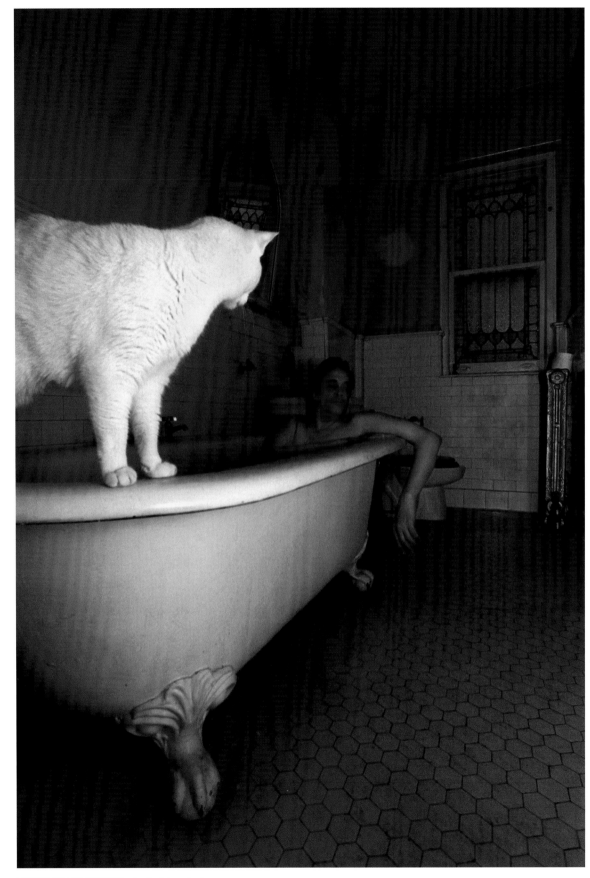

DOUGLAS FURGUSON | fashion designer

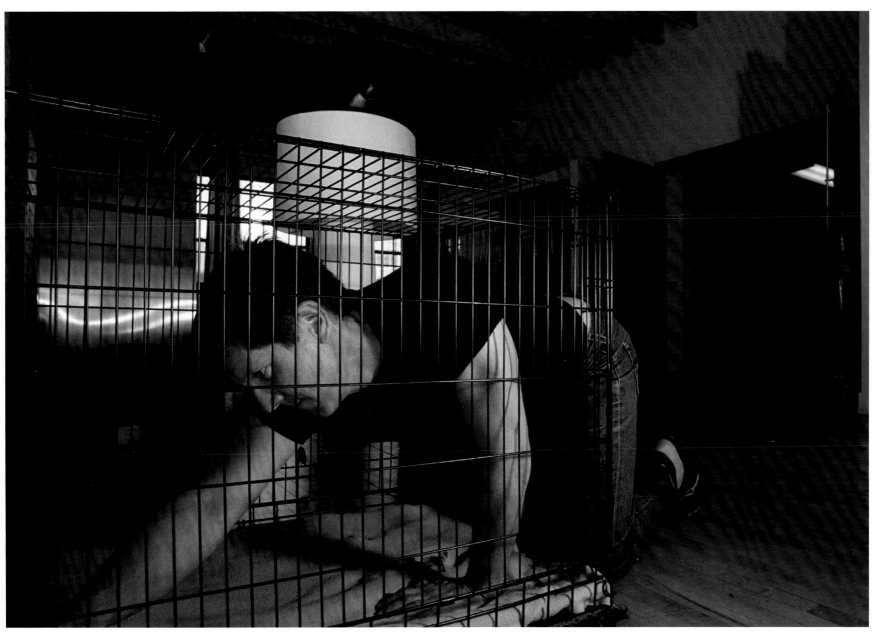

JONATHAN BURNHAM | publishing executive

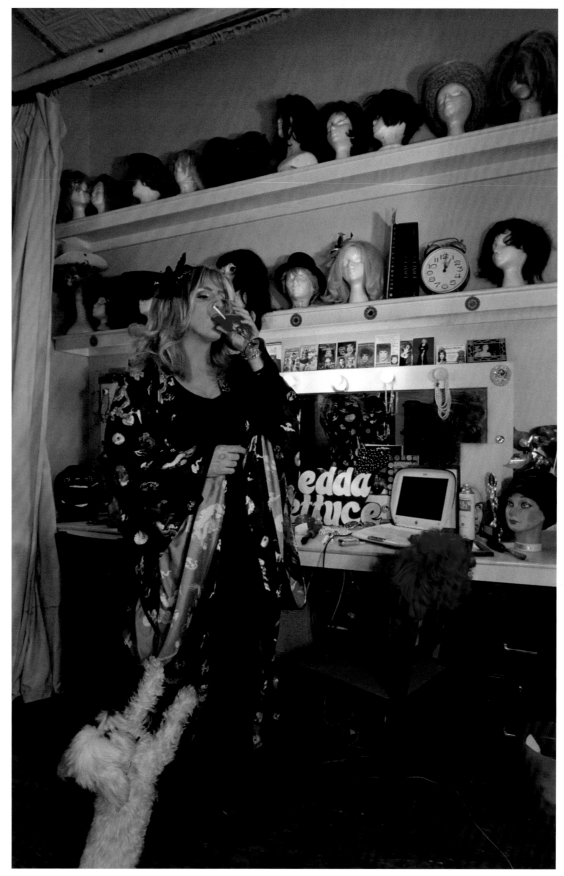

HEDDA LETTUCE | drag queen | about to leave for a performance

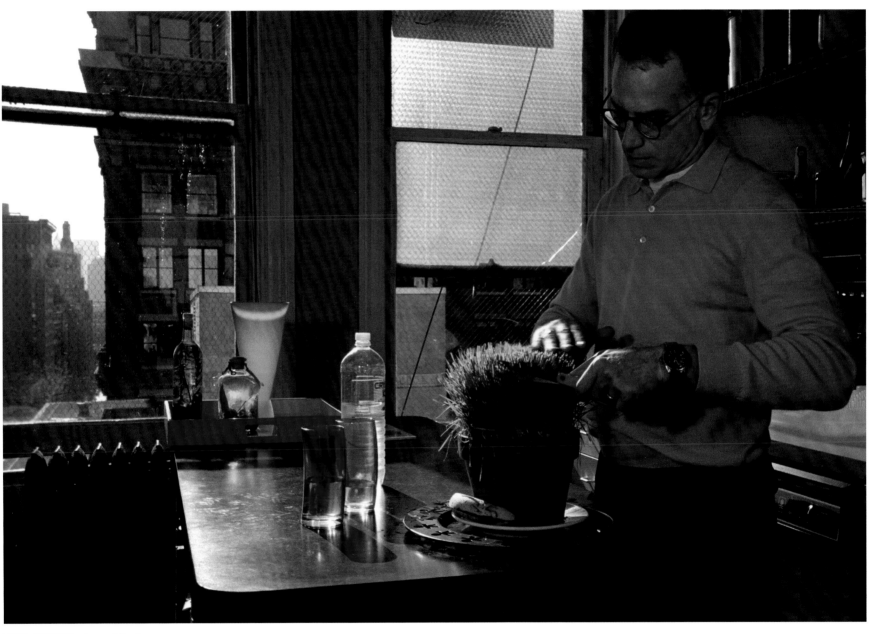

PAUL AFERIAT | architect

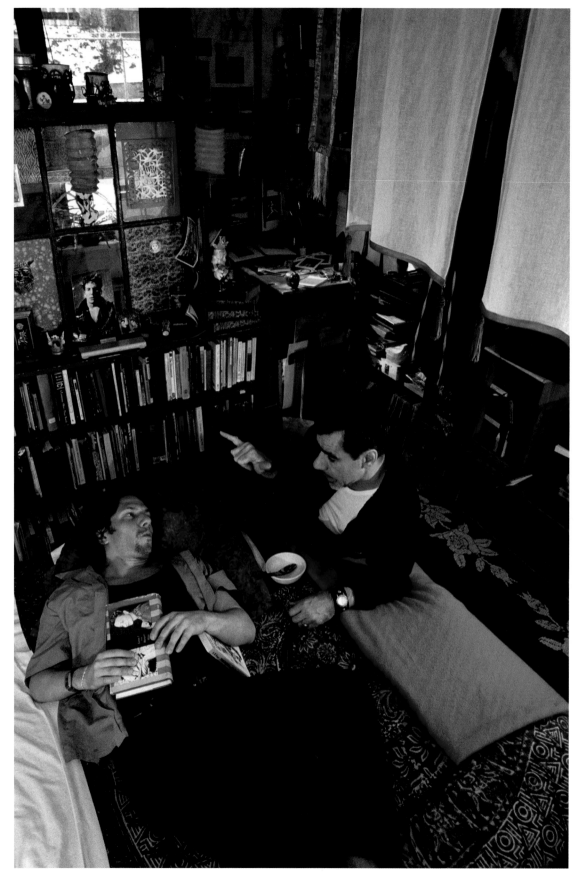

TOM VALETTE and **DARRELL WILSON** | teachers | conversing in sign language

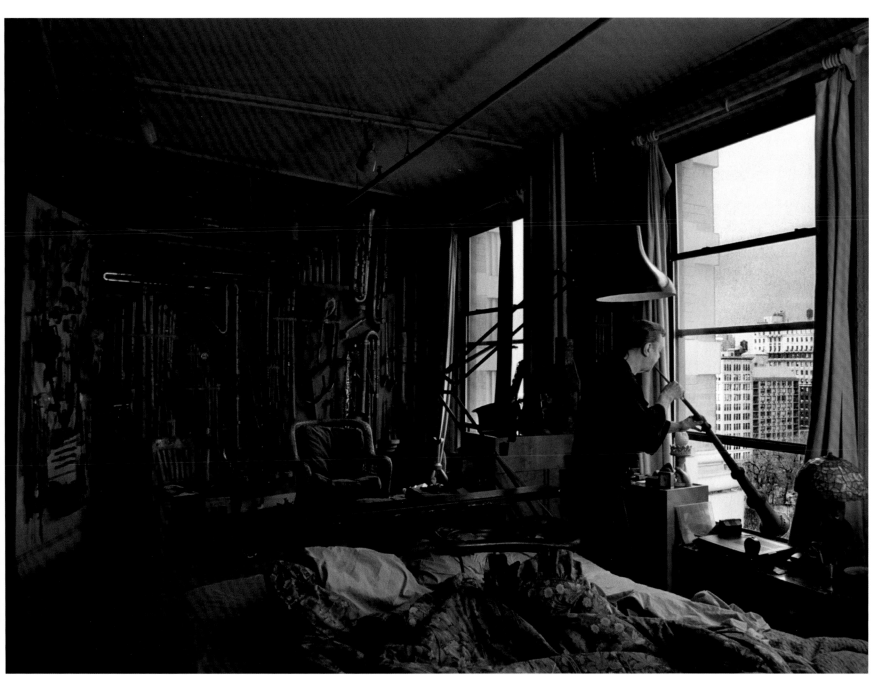

TOM O'HORGAN | director of *Hair* and *Jesus Christ Superstar* | playing a song to Union Square

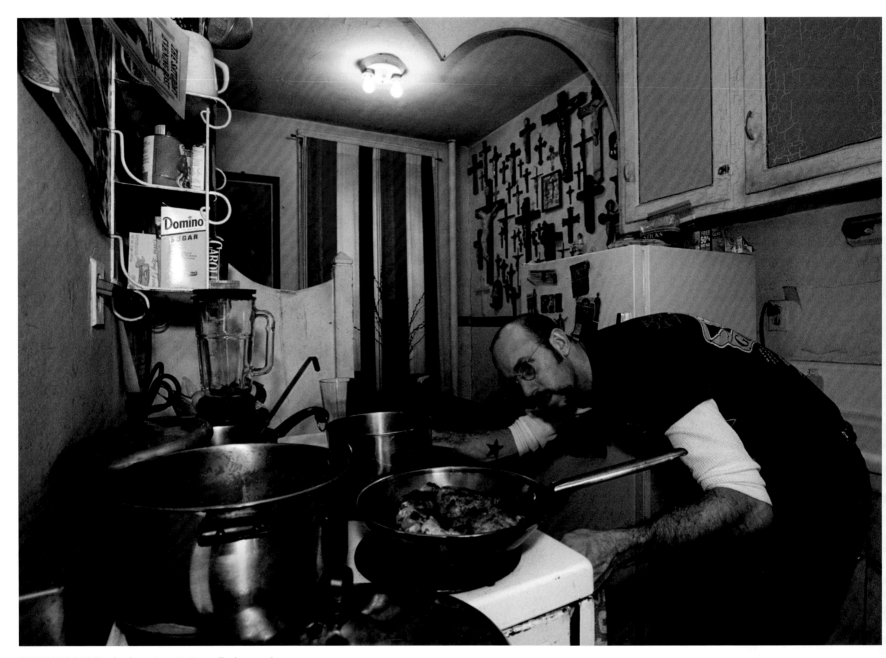

MARK VITULANO | department store display producer

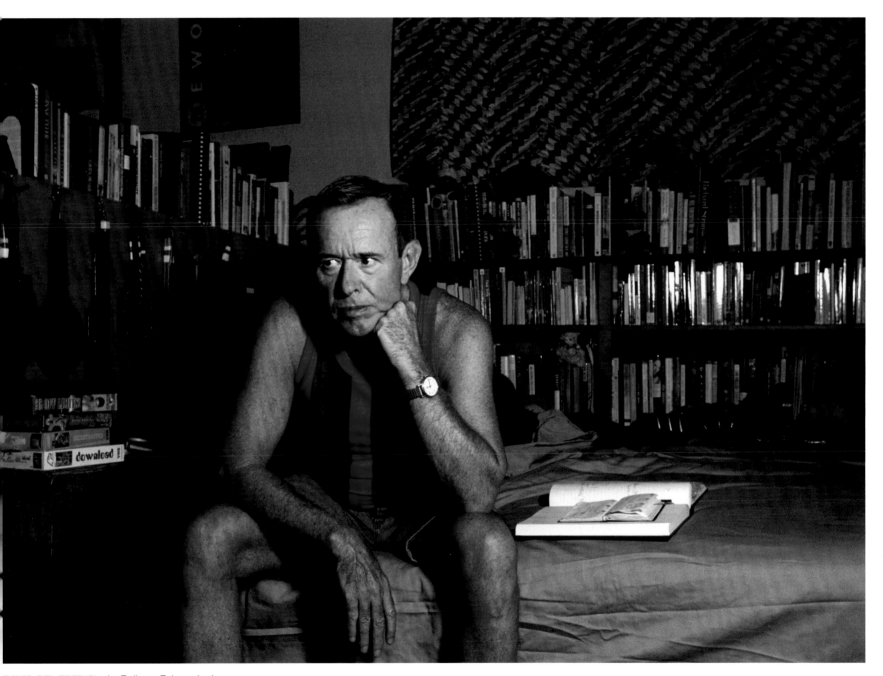

DAVID DEL TREDICI | Pulitzer Prize–winning composer

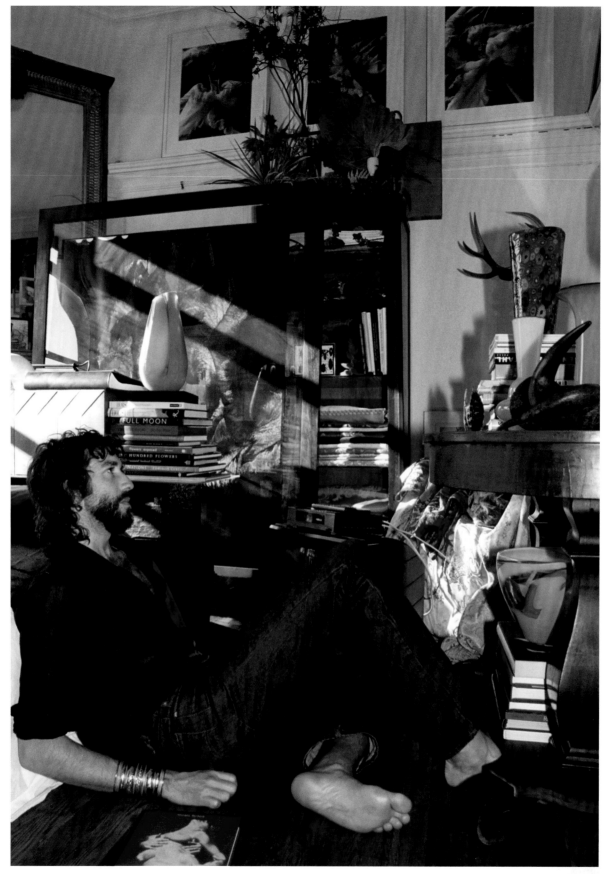

CHRIS BEANE | photographer

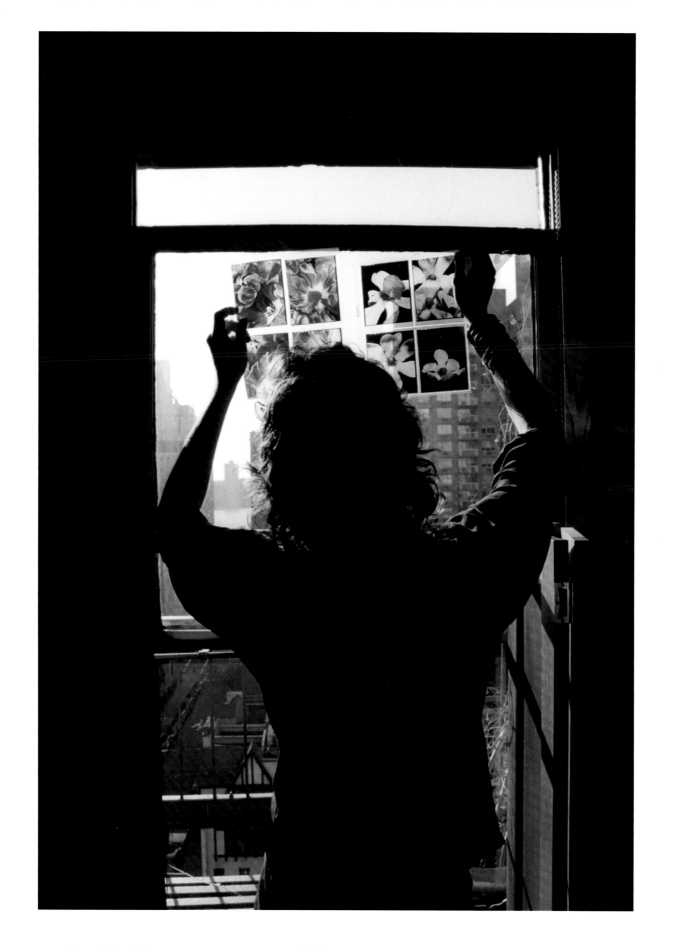

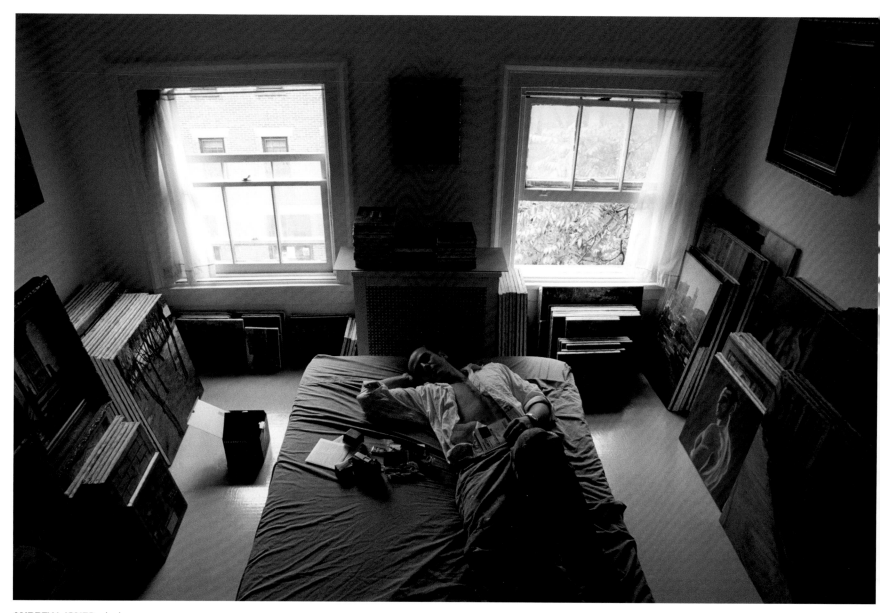

ANDREW JONES | lawyer

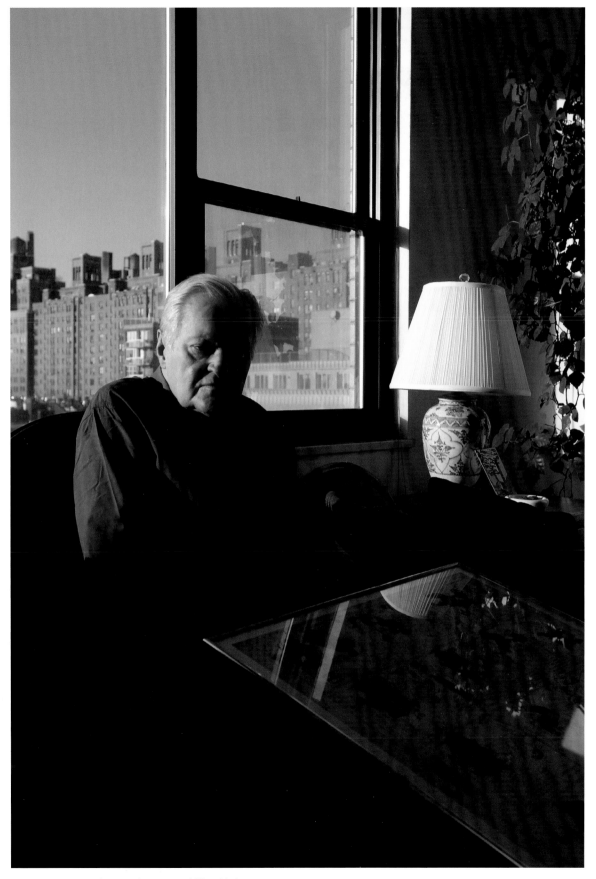

JOHN ASHBERY | poet laureate of New York

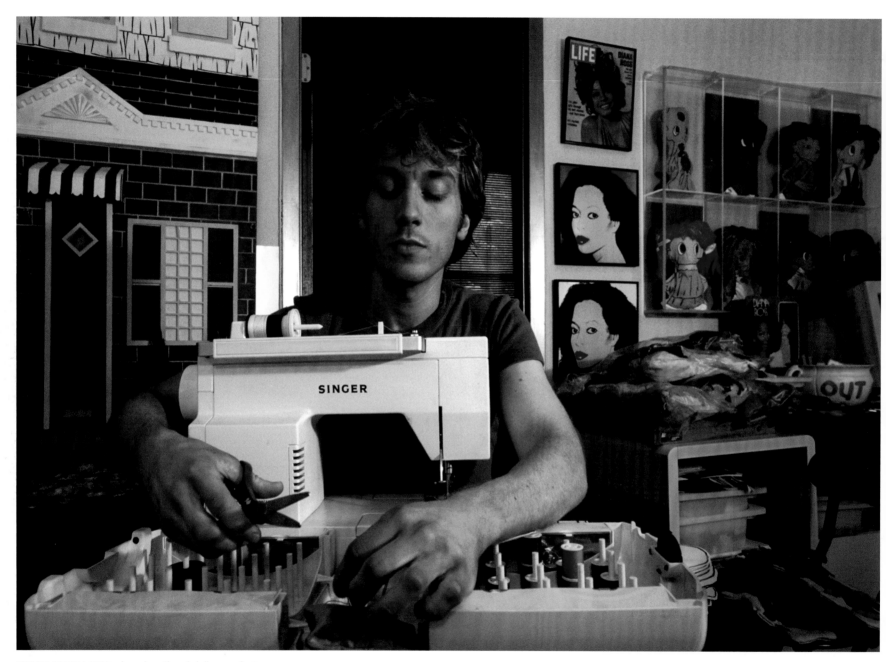

TIMOTHY BELLAVIA | educational doll manufacturer

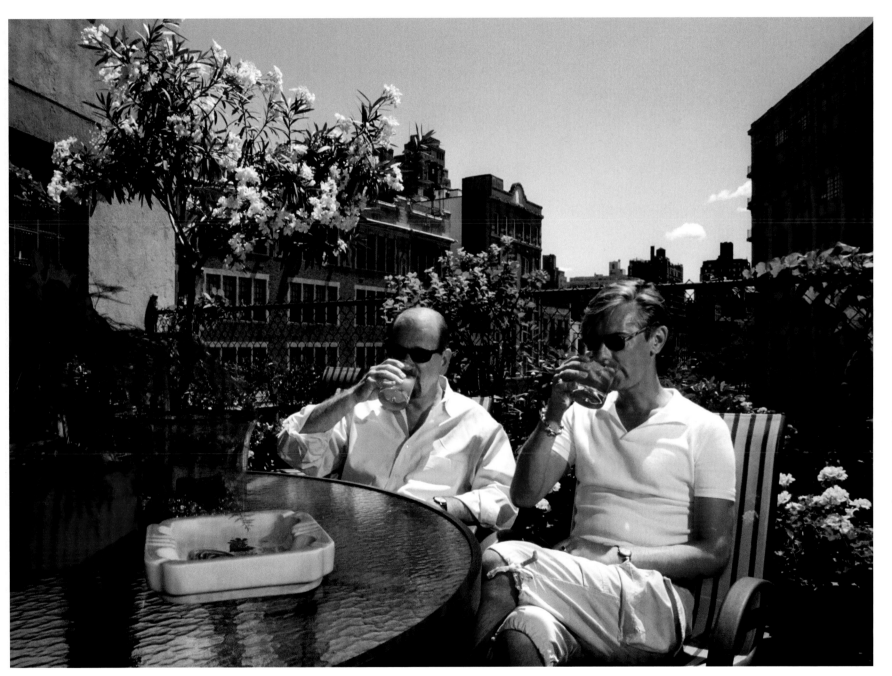

SAM CARSON | retiree | **GARRETT YEBERNETSKY** | interior designer | just before moving to Florida

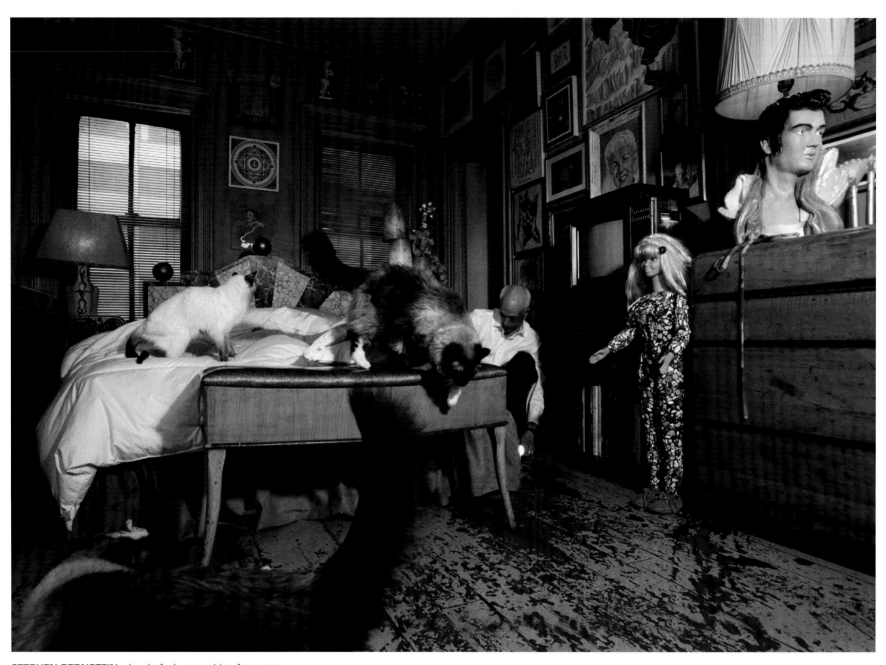

STEPHEN BERNSTEIN | chef | searching for a cat

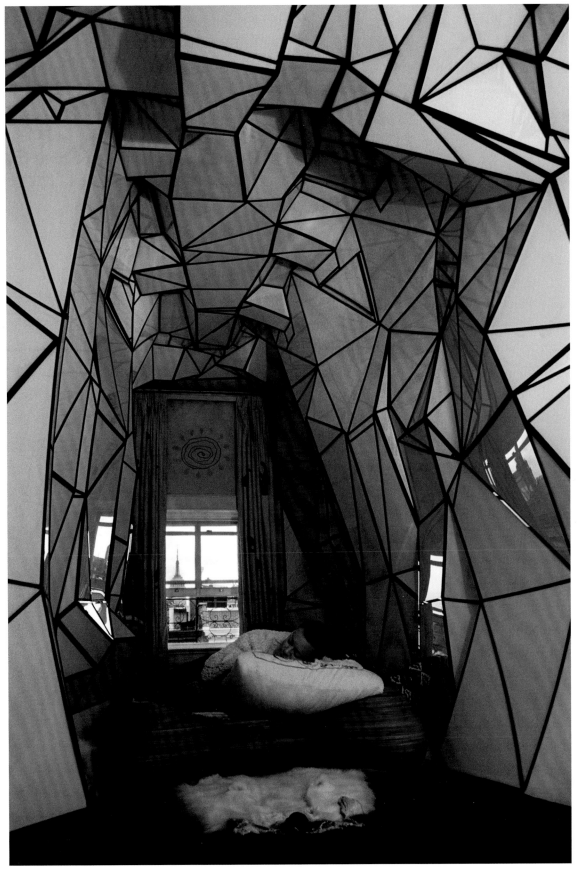

ANDREW SOLOMON | National Book Award–winning writer and depression researcher

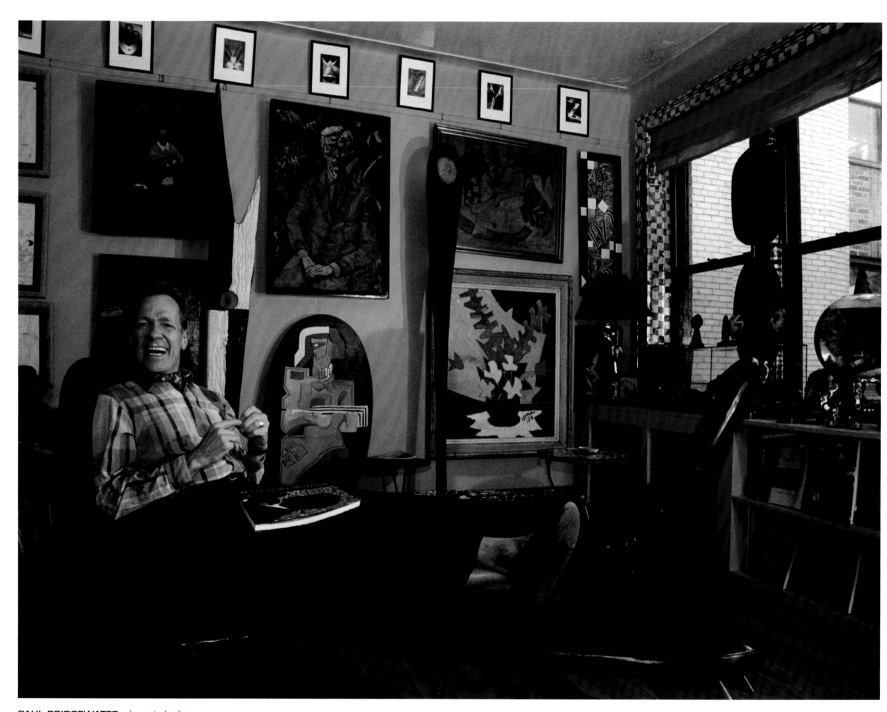

PAUL BRIDGEWATER | *art dealer*

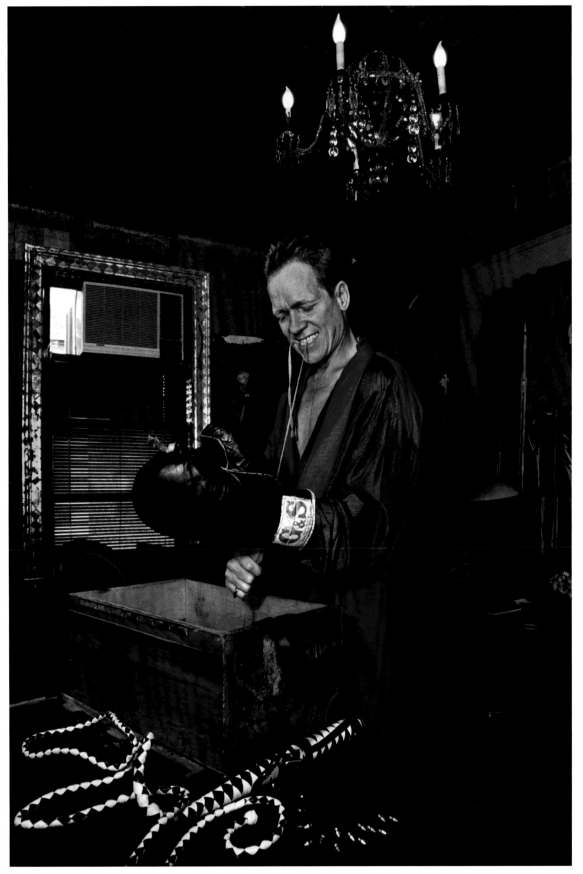

in his bedroom

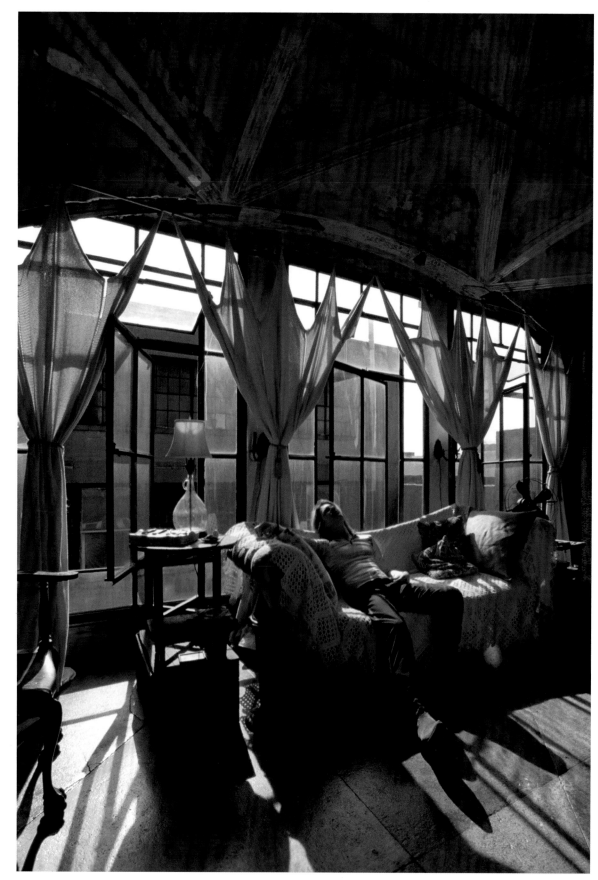

BILLY BASINSKI | composer

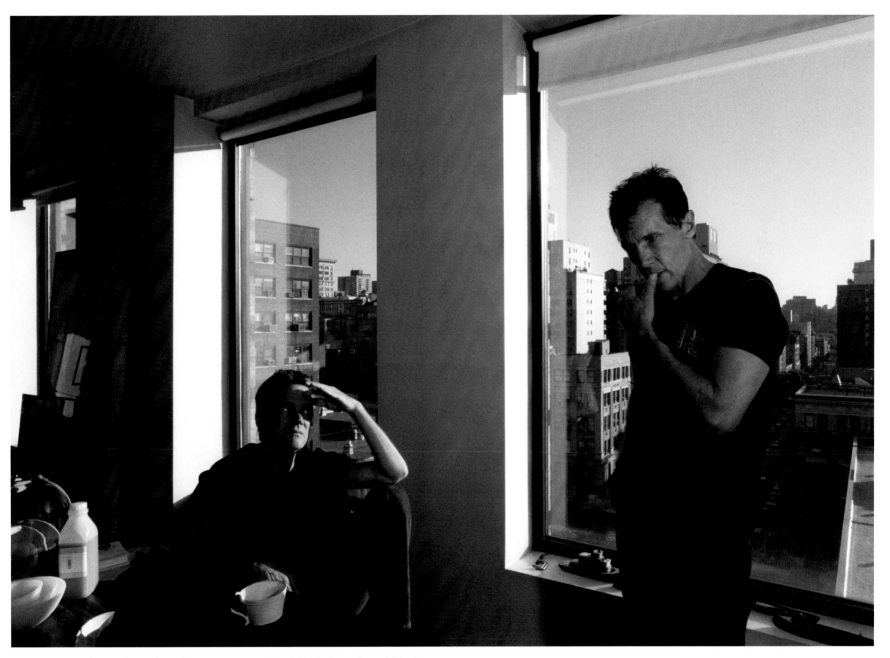

KEN CORBETT | psychoanalyst | **MICHAEL CUNNINGHAM** | author of *The Hours*

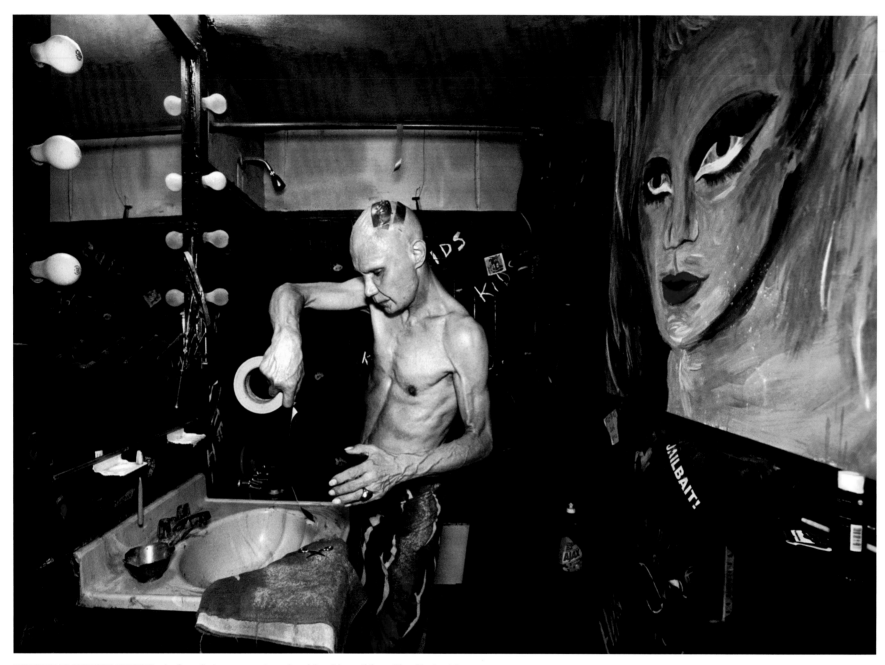

MOTHER FLAWLESS SABINA | female impersonator | giving himself face lift with duct tape

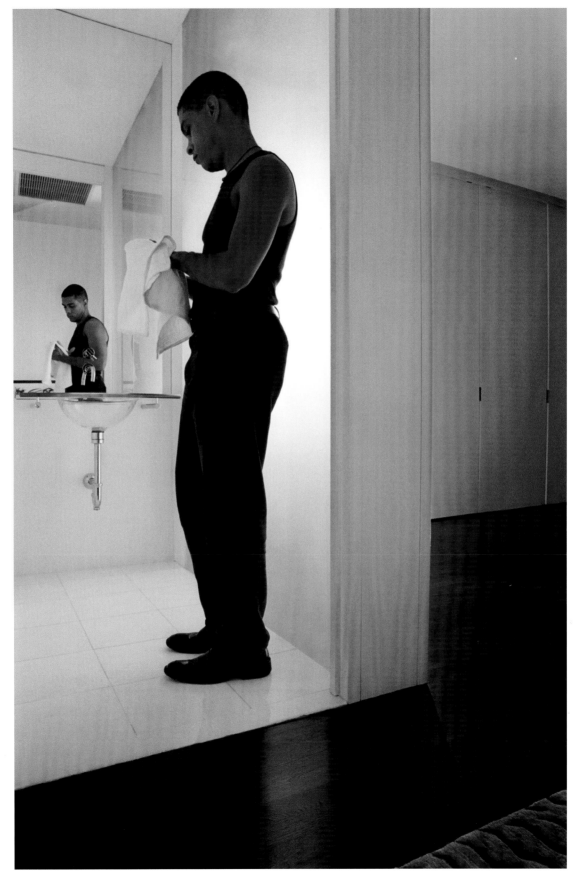

KYLE KIMBALL | investment banker

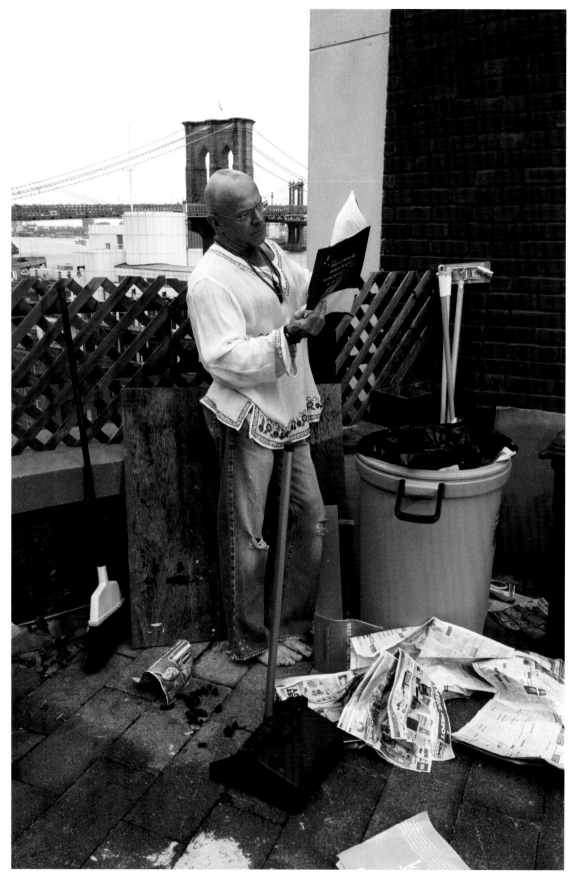

JUNIOR VASQUEZ | DJ

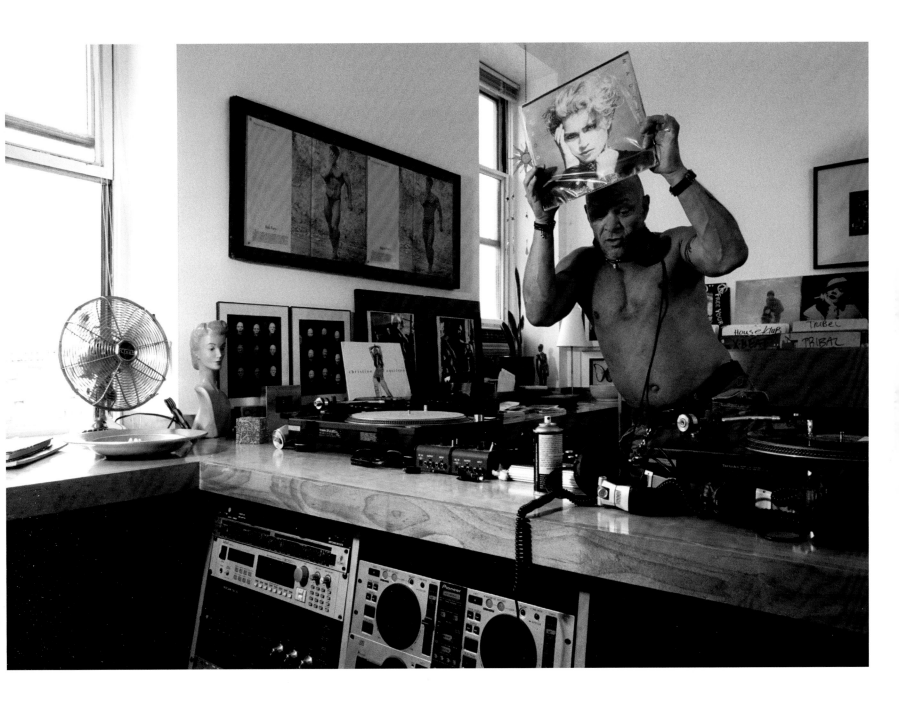

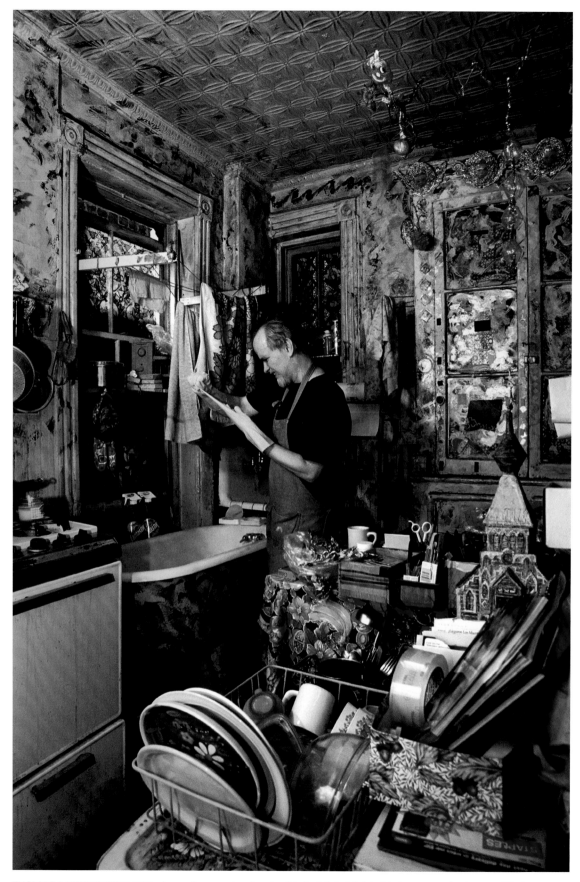

THOMAS LANIGAN-SCHMIDT | professor | cleaning his bathtub/sink in his tenement bathroom/kitchen

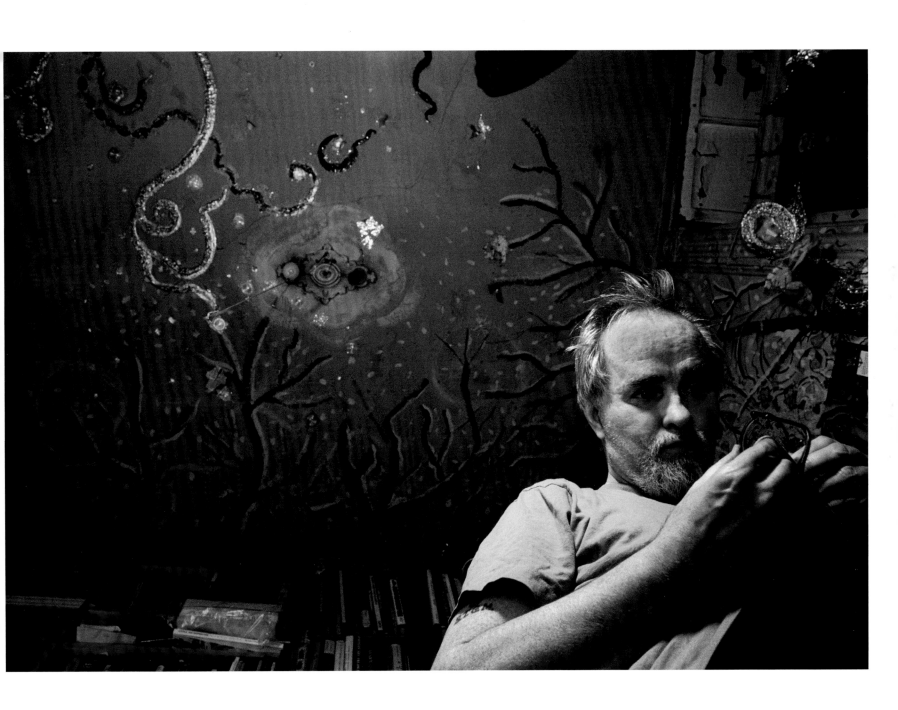

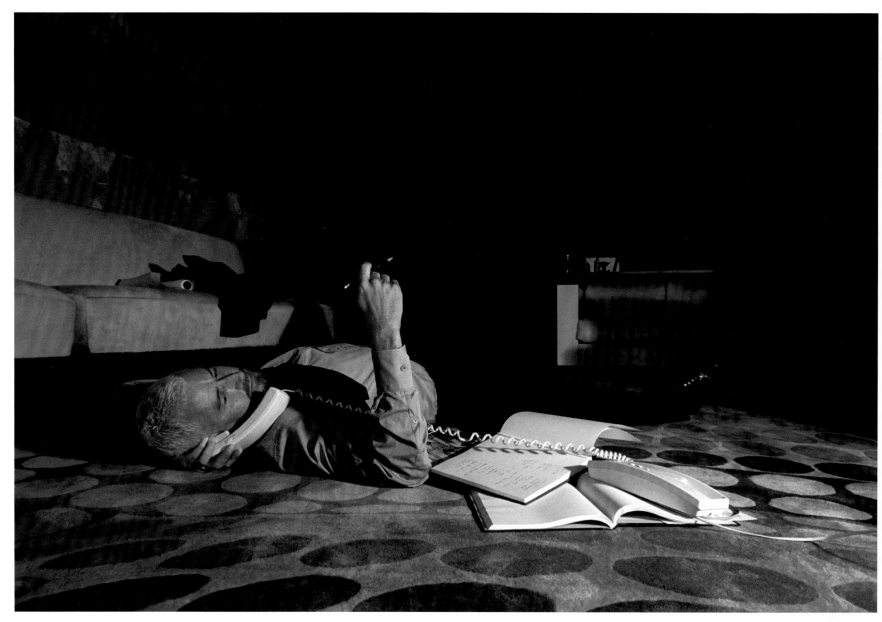

BILL SOFIELD | chief architect of Gucci stores

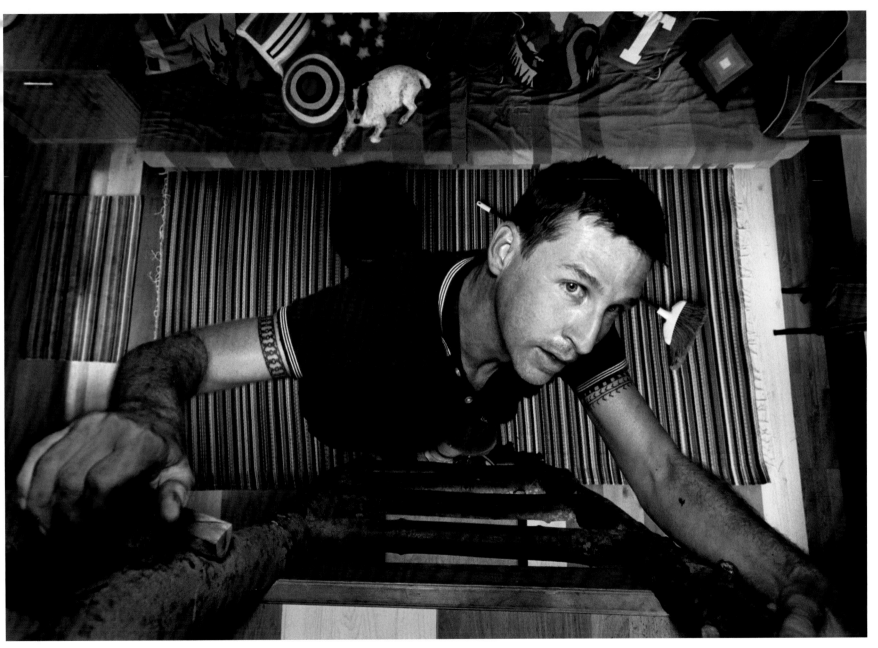

TODD OLDHAM | designer | climbing his tree house

BIOGRAPHIES

TOM ATWOOD

Tom Atwood specializes in urban location portraiture, exploring people in their built environments throughout the world. Each of Atwood's photographs strives to be a work of art in its own right, making particularly creative use of strong detail and vibrant color. His informal interaction with subjects also creates the experience of chance and intimacy.

Atwood's work exhibits in New York, Miami, San Francisco and Los Angeles, most recently at ClampArt on West 25th Street in New York and Louis Stern Fine Arts on Melrose Avenue in Los Angeles. Atwood's work has also been exhibited at the Museum of Modern Art in New York and the George Eastman House / International Museum of Photography and Film.

Atwood was named one of the Top 100 Photographers by the Golden Light Awards. He has won several additional awards including from Kodak, the Applied Arts Photography Annual and the Advertising Photographers of America Association, in an international competition sponsored by the Getty Museum and the Armand Hammer Museum. His work has been in dozens of books and periodicals, including *PDN Magazine, Genre Magazine, Wraparound Magazine, Se7en Magazine, LA Confidential Magazine, Applied Arts Magazine* and *The Advocate Magazine.*

Atwood also has a bachelor's degree from Harvard University and a master's degree from Cambridge University. Before he moved to LA, his studio was at different times based in San Francisco, New York, Paris, and Amsterdam. More on Atwood is available at www.TomAtwood.com.

CHARLES KAISER

Charles Kaiser is the author of *1968 in America* and *The Gay Metropolis.*